The Whyte Museum of the Canadian Rockies Presents

BEARS

Tracks through Time

BY MICHALE LANG

RMB

Victoria Vancouver Calgary

Rocky Mountain Books
www.rmbooks.com

Library and Archives Canada Cataloguing in Publication

Lang, Michale, 1956-
 Bears : tracks through time / by Michale Lang.

At head of title: The Whyte Museum presents.
Includes bibliographical references and index.
ISBN 978-1-897522-82-0

 1. Bears—Effect of human beings on—Rocky Mountains, Canadian (B.C. and Alta.)—History. 2. Bears—Effect of human beings on—Rocky Mountains, Canadian (B.C. and Alta.)—Anecdotes. 3. Bears—Behavior—Rocky Mountains, Canadian (B.C. and Alta.)—Anecdotes. 4. Rocky Mountains, Canadian (B.C. and Alta.)—Biography.
 I. Whyte Museum of the Canadian Rockies II. Title. III. Title: Whyte Museum presents bears.

QL795.B4L35 2010 599.78'09711 C2009-907205-X

Printed in Canada

Rocky Mountain Books acknowledges the financial support for its publishing program from the Government of Canada through the Canada Book Fund (CBF), Canada Council for the Arts, and the province of British Columbia through the British Columbia Arts Council and the Book Publishing Tax Credit.

BRITISH COLUMBIA
ARTS COUNCIL
Supported by the Province of British Columbia

Canada Council
for the Arts

Conseil des Arts
du Canada

This book has been printed with FSC-certified, acid-free papers, processed chlorine free and printed with vegetable-based inks.

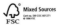

Mixed Sources
Cert no. SW-COC-001271
© 1996 FSC
FSC

Dedicated to Richard Lang and Churyl Caldwell (Mom), my greatest supports

With Special Thanks To

Dagny Dubois

Lena Goon

E.J. (Ted) Hart

Elizabeth Kundert-Cameron

Heather Lohnes

Bob Pearson

CONTENTS

Year after year they have come and gone. The passing travellers see them. The men of the hotel know many of them well. They know that they show up each summer during the short season when the hotel is in use, and that they disappear again, no man knowing whence they come or whither they go.

Ernest Thompson Seton, *The Biography of a Grizzly*, 1899

Grizzly, Dan Hudson, acrylic on canvas

My interaction with bears began in 1971 when I moved to the small mountain town of Field, BC, in Yoho National Park. Nearly every summer night I would come across a bear rifling through the garbage cans on our quiet streets. Always maintaining a wide berth, I would walk past safely as the bear continued looking for leftovers. I did not feel overly threatened during any of these encounters, but each one did leave me feeling fortunate. What I did not realize at the time is just how much those bears and I had in common. They too were fortunate. While I had safely passed a very strong and opportunistic carnivore, the bear had avoided another potentially fatal confrontation with a human. In a way, we were both survivors.

For those of us living in the Canadian Rocky Mountains, bears are our neighbours. We run into each other from time to time, but the bears mostly keep to themselves. Humans and bears are usually very good neighbours. Yet, occasionally there is a disagreement. Misunderstandings, unpredictable behaviour or just plain bad timing can lead to humans provoking the fights, but sometimes bears do attack for no apparent reason. Stories about what starts these clashes are actually not so different from those we read in local newspapers about confrontations between humans. The stories do often differ in how they end though. Once a bear becomes a nuisance or acts violently toward humans, it is often relocated or shot. Therefore, regardless of whether the human or the bear is responsible for starting a fight, the bear usually pays the ultimate price.

To honour our close habitation, the Whyte Museum of the Canadian Rockies has accumulated an important collection of art, artifacts and archival materials related to bears. This book features images and stories from that collection, along with selected artworks from past and future exhibitions at the Museum. Rather than being

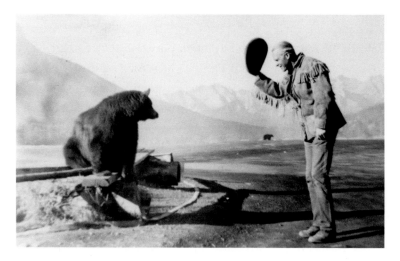

Captain Conrad O'Brien-ffrench and bear at Banff Nuisance Grounds

an exhaustive study of bears, this is a journey along the trail of bear tales within the Museum's collection. These stories help to clarify the history of our relationship with these beautiful – and sometimes frightful – creatures.

Following the tracks of bears through their part of the Whyte Museum's collection illuminates a diverse range of relationships throughout time. The First Nations people, having populated this area for over ten thousand years, maintain a deep reverence for these great mammals. The combination of First Nations' oral storytelling tradition, along with artifacts bearing claws and teeth, work together to create vivid images of successful hunts. Explorers passing through the Rockies were some of the first to textually record their own encounters with bears. Artists also increasingly depicted the impressive beasts on paper or canvas.

In 1885, two events occurred that sparked significant transformations in the Canadian Rockies. First, the Hot Springs Reservation was established, which eventually grew to become Rocky Mountains Park, Canada's first national park (officially becoming Banff National Park in 1930). Second, in November of 1885, the last spike completed

the transcontinental Canadian Pacific Railway. Both of these events defined the area and created new transportation routes to get there, ushering in the beginning of tourism's increasing presence in the region. With the arrival of Banff's first transcontinental passenger train in June 1886, the development of tourism in the Canadian Rockies was in full swing.

Fascination with the area's bears took a menacing turn as more hunters, tourists and entrepreneurs travelled to the Rocky Mountains. It became common to kill bears for museum exhibitions, trophies and souvenirs, or to capture the animals for zoo exhibits and tourist entertainment. Whether chained in front of businesses, meandering down streets or grazing in local garbage dumps, bears captured the attention of locals and tourists alike. For a time, the bears' role was as a lovable natural clown. Nevertheless, as exposure to bears increased, so did the stories of bears biting the hands that were trying to feed them. Reports of bear attacks began to filter out, which ushered in the realization that bears really were wild animals. Despite the fact that human behaviour was significantly contributing to the so-called "bear problem," the solution was usually to call a warden. Wardens, the very people charged with protecting wildlife, have all too often had to dispose of a "problem bear."

Many of us now have a different image of bears: one of reverence tinged with fear. Bears have become an icon of the Rocky Mountain wilderness. Sadly, past and present human behaviour continues to have an immense impact on the long-term survival of bears. Humans continually encroach upon bear habitat, which is disappearing at an alarming rate. We restrict their movement along the corridors that are essential to their existence. Many bears die as they try to negotiate their way across highways and railway tracks. It is essential that we try to further understand how we can share habitat with bears, rather than destroying them and the territory that supports them.

Of the eight species of bears on earth, the International Union for the Conservation of Nature has listed only the American black bear

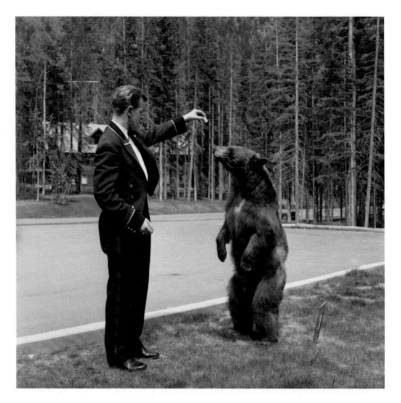

Man feeding a bear

as secure throughout their natural geographic territory. According to their extinction risk, the seven other species are endangered or vulnerable to varying degrees. The Alberta Endangered Species Conservation Committee's 2002 report stated that the declining number of bears is because of a serious compromise of their habitat due to: recreational activity, clear-cuts, oil wells and the roads left behind when those industries move on. Yet, despite research and recommendations, meaningful steps to further protect bears have yet to be taken.[1] Protecting our wild neighbours from further threat is not a "bear problem." It is a human problem. If we are to share our future with bears, we must increase our efforts to protect the powerful creatures that we both fear and admire. Otherwise, we may only have images like these to remember them.

Whyte Museum's Collecting Area: the Canadian Rockies

The Whyte Museum's collecting mandate geographically includes the mountainous areas of Canada bounded by the 49th parallel on the south, the Peace River on the north, the Front Ranges on the east, and the Columbia Mountains on the west. Materials from the Town of Banff, Banff National Park and the Upper Bow Valley are prominent in these collections. The Archives and Library mandate also includes materials on mountain recreation and Canada's national parks.

Map of Whyte Museum's collecting area

CHAPTER ONE

So every living thing that moved, and every flower that grew, and every rock and stone and shape on earth told out its tale and sang its little story to his nose.

Ernest Thompson Seton, *The Biography of a Grizzly,* 1899

Mother grizzly and yearling cubs

The Bear Facts

Within the Canadian Rocky Mountains, there are four mountain national parks: Banff, Yoho, Jasper and Kootenay. Two species of bears live in this region: black bears (*Ursus americanus*) and grizzly bears (*Ursus arctos horribilis*). All bears are protected from hunting within the national parks.

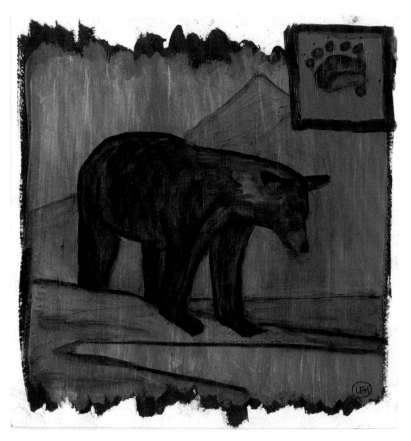

Black Bear and its track, Lynne Huras, dry pastel, acrylic, acrylic medium on paper

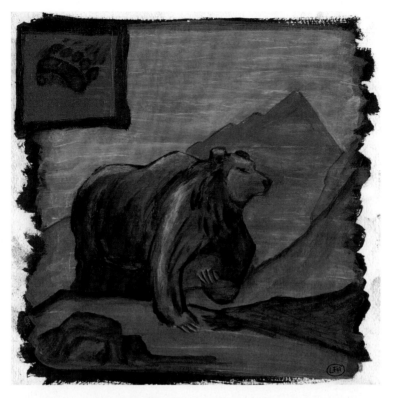

Grizzly Bear and its track, Lynne Huras, dry pastel, acrylic, acrylic medium on paper

Differences between Black Bears and Grizzly Bears

Black bear habitat overlaps with grizzly bear habitat, although grizzlies are slightly more prone to open country. Appearance is not always reliable in determining the difference between black and grizzly bears. Thus, the more common black bears are sometimes mistaken for grizzlies. At various stages of growth, black and grizzly bears can be of similar size, with black bears weighing between 90 – 150 kilograms (198 – 330 lbs.) and grizzly bears between 130 – 400 kilograms (286 – 880 lbs.). To complicate matters further, both of their names can be misleading. The name grizzly comes from the grizzled appearance

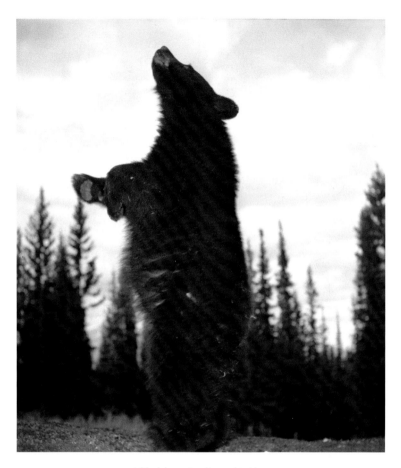

A black bear standing on hind legs

that results from silver-tipped guard hairs protruding through the coat of many – but not all – grizzlies. Grizzly coats range in colour from nearly black to whitish. Black bears can be black, but they can also be brown, honey-coloured or white.

If not all grizzlies are grizzled and not all black bears are black, how do we tell the difference between the two species? It is not always easy to see, but grizzlies have a pronounced hump at their shoulders and black bears have little or no hump. The chart below outlines some of their similarities and differences. For instance, grizzlies are excellent

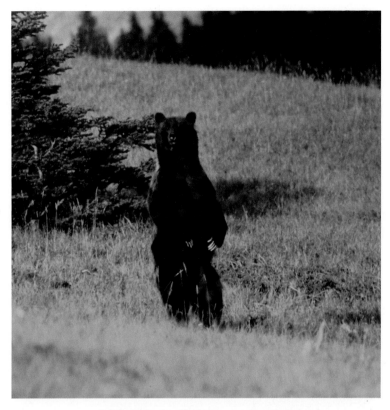

Grizzly cub rears and looks at camera in curiosity

swimmers, but cannot climb trees. Alternatively, black bears can climb trees but are not quite as talented aquatically. Two points to remember are that these bears have a strong sense of smell and can run at least twice as fast as a human. In fact, grizzlies reportedly have a sense of smell that is seven times better than a hound dog (which has a sense of smell three hundred times better than we do). It is likely that these bears *will* pick up your scent. As F.H. (Bert) Riggall, lifelong Rocky Mountain guide and outfitter said, "He can take one sniff of you half a mile downwind and tell you the colour of your grandmother's wedding dress."[2] If a bear investigates that scent and confronts you, always remember . . . do not try to outrun a bear!

Characteristics	Black bear	Grizzly bear
Ears	Larger, more elongated ears	Smaller looking, rounder ears
Snout	Snout and forehead tend to run together in a straight line	Snout protrudes from "dish-shaped" face
Throat	Smooth throat	Ruff of coarse hair beneath chin
Claws	Dark, rarely noticeable	Long, often pale-coloured
Length	1.2 – 1.9 m (3.9 – 6.2 ft.)	1.2 – 2.5 m (3.9 – 8.2 ft.)
Vision	Colour vision	Poor eyesight
Sense of Smell	Keen sense of smell	Acute sense of smell
Hearing	Acute sense of hearing	Acute sense of hearing
Weight	90 – 150 kg (198 – 330 lbs.)	130 – 400 kg (286 – 880 lbs.)
Climbing	Good tree climbers	Cannot climb trees
Swimming	Good swimmers	Excellent swimmers
Home Range	Male: 100 – 475 km² (38 – 180 mi.²) Female: 20 – 300 km² (8 – 115 mi.²)	Male: 1000 – 2500 km² (385 – 965 mi.²) Female: 200 – 500 km² (77 – 190 mi.²)
Speed	Speeds of up to 55 km/h (34 m.p.h.)	Speeds of up to 48 km/h (30 m.p.h.)
Do not try to outrun a bear!		

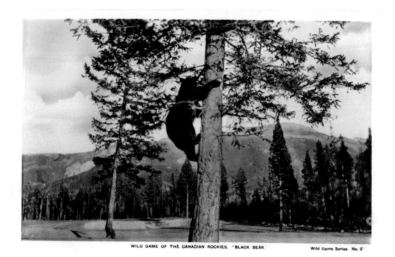

WILD GAME OF THE CANADIAN ROCKIES. "BLACK BEAR" Wild Game Series No. 5

Postcard of black bear in Wild Game series, J. Fred Spalding, photographer

Grizzly bear

Hungry as a Bear

To survive the long winters, bears of the Rocky Mountains need to eat voraciously throughout the few snow-free months. As such, they must consume enough food for the whole year within a period of five to seven months, depending on the species and environmental factors. Research indicates that bears can consume up to 20,000 calories of food energy per day. With food sources varying between seasons and landscapes, the bears must travel extensively to meet these nutritional requirements. Humans may see themselves as being at the top of the food chain, but bears are custom-made eating machines. As Andy Russell said, "[The bear's] stomach is his passport to paradise."

Black bears can endure without food for up to seven months. To prepare for their period of dormancy, they eat mostly berries, nuts, grasses, carrion and insect larvae. Grizzly bears also eat a variety of plants, with meat constituting only 15 per cent of their diet. All bears are opportunistic carnivores.

According to Parks Canada, the typical diet of grizzly bears changes according to the season. In the spring and early summer they eat:

> Hedysarum roots
> Glacier (snow) lily bulbs
> Spring beauty bulbs
> Grasses and sedges
> Clover and dandelions
> Horsetails (Equisetum)
> Cow parsnips
> Winter-killed animals
> Newborn calves of elk, deer or moose

In the late summer and fall, the grizzly bears' diet consists of:

> Buffaloberries (as many as 100,000 per day)
> Currant berries
> Blueberries/huckleberries (west of the Great Divide)
> Bearberries

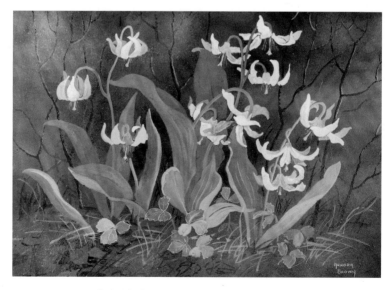

Snow Lily, Annora Brown, watercolour on paper

Spring beauty, lantern slide

- Crowberries
- Grouseberries
- Whitebark pine nuts
- Hedysarum roots (especially if berry crop fails)
- Ants and ant larvae/grubs
- Ground squirrels and marmots
- Deer, mountain goats, sheep or elk

Hibernation

We only see or hear about bears in summer because they hibernate in the winter months, right? In fact, bears are not true hibernators. Bear metabolism and body temperature do not go through the same kinds of changes as in hibernators like squirrels. Bears do enter a state of dormancy in winter months, but it is possible for them to wake up if necessary. In the Canadian Rockies, bears usually go to their dens with the first real snow around early November and emerge in April.

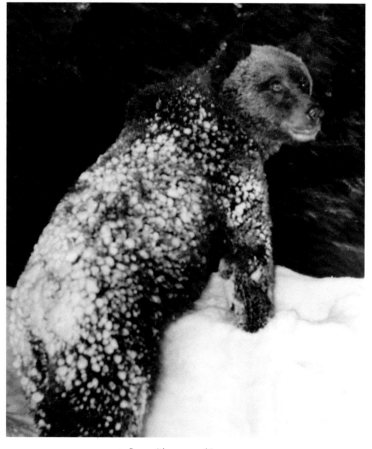

Bear with snow on his rump

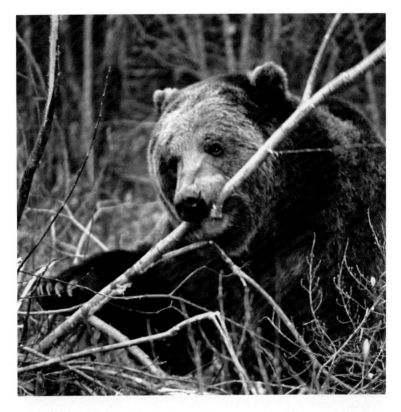

Grizzly bear chewing on a branch

Angry as a Bear?

Are bears ferocious, angry beasts or curious, lovable clowns? Although bears are not inherently dangerous to humans, neither are they harmless if they feel threatened. Most people do not spend enough time with bears to understand their behaviour or what poses a threat to them. In a discussion with Mike Gibeau, Parks Canada Carnivore Specialist, he elaborated on how each bear has its own personality; some bears are loners, while others are gregarious and seek the company of other creatures, including humans.

There are many observations of bears' curiosity, but one of my favourites is from an unpublished manuscript from the 1950s titled *In the Shadow of the Peaks*, by amateur historian Mabel Brinkley:

> The bear is a curious animal. If he sees something fluttering in the breeze he will break a flagpole down to see what and why the object is. Curiosity gratified, he goes his way satisfied. Any bear can climb numerous trees, walk out on a limb, past the fence line and drop down on the course, but it is seldom induced to do it unless curiosity leads him to investigate what he does not understand.

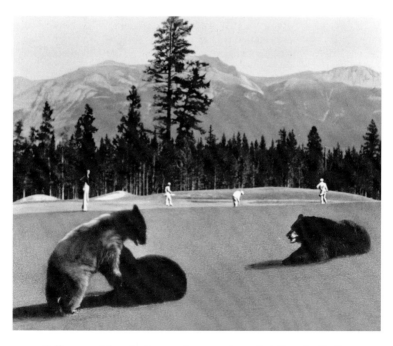

Golfers are not the only players on the course, Jasper Park, Canadian Rockies

In the Rocky Mountains, bears sometimes wander into recreational areas such as golf courses. Humans tend to forget that these groomed areas are still surrounded by wilderness habitat.

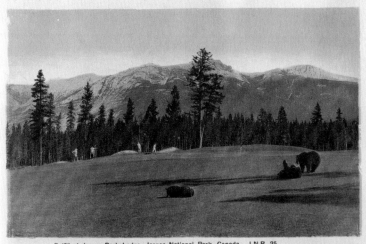

Golf" at Jasper Park Lodge, Jasper National Park, Canada. J.N.P. 25.

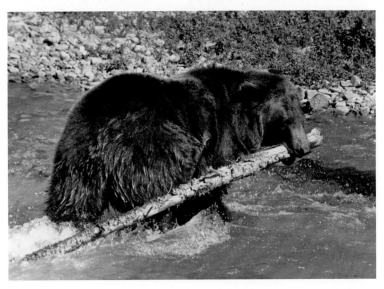

Grizzly bear dragging a branch in the river

Bears Breed Slowly

Bears can live more than 25 years in the wild, but it takes several years before they reach sexual maturity. Once mature, female bears only breed every few years and produce litters of one to four cubs. Thus, they reproduce at a much slower rate than other mammals. Currently, the loss of females threatens the bear populations in the mountain national parks.

Although they breed slowly, bears are well adapted to the harsh life of the Canadian Rocky Mountain wilderness. From mid-May to early June, male grizzlies often travel far to find an available mate. After mating, female grizzlies experience delayed implantation: the embryo only implants in the uterus in November or December if the mother has enough fat reserves to nourish her and the developing fetuses throughout the dormancy period. Female black bears are also capable of delayed implantation. Cubs are born toothless, blind, bald and weighing not even half a kilogram (less than a pound). They nurse on fatty milk for several more months while the mother continues to slumber. Grizzly cubs remain with their mother for at least three years, while black bear offspring usually separate from the sow when they are 16 to 17 months old. Male bears are not involved in raising cubs. In fact, male grizzly bears sometimes kill cubs to get a chance to mate with the mother.

CHAPTER TWO

We talked to the rocks and streams, the trees, the plants, the herbs, and all nature's creatures. We called the animals our brothers. They understood our language; we, too, understood theirs. Sometimes they talked to us in dreams and visions. At times they revealed important events or visited us on our vision quests to the mountaintops. Truly, we were part of and related to the universe, and these animals were a very special part of the Great Spirit's creation.

Chief John Snow, *These Mountains Are Our Sacred Places*, 1977

Brown bear necklace in birchbark basket

First Nations and Bears

The majority of the Whyte Museum's collection of First Nations artifacts is from the Stoney Nakoda people. The Museum's founders, Peter Whyte (1905 – 1966) and Catharine Robb Whyte (1906 – 1979), were both artists who had many close friends from the nearby Stoney Reserve at Morley. Throughout their lives, Peter and Catharine painted numerous portraits of their Stoney friends, received many beautiful Stoney artifacts as gifts and purchased some items directly from the Stoney people.

With great respect for the rituals and customs of First Nations peoples, the Whyte Museum does not publish or exhibit artifacts with special significance from the collection. Elder Jonas Dixon relates how, when a bear is brought down by a Stoney hunter, certain parts are buried in secret ritual:

> Most of a bear - skin, bones, claws, teeth, ears, tongue, genitals - have sacred ritual and medicine rite uses. These rituals and rites are the secrets of Stoney Bear dreamers and Stoney Bear men . . . Great Bear listens to the songs of the Stonies and releases the medicine powers within his heart or claws or tail and teeth.[3]

For example, the collection includes a necklace, made of adult and baby grizzly claws, that has red ochre on it. The red ochre signifies that its original use was ceremonial. Corleigh Belton, a contemporary Stoney medicine woman, advises that to make such an item public would "offend the Grandfather Grizzly Bear because such things are kept very, very quiet and passed on from one generation to another."[4] This necklace likely belonged to a shaman.

Stoney Nakoda

The Sioux Nation consists of three groups of First Nations people: the Eastern Dakota, the Nakoda and the Lakota. These three groups differ by where they live and the dialect they speak. Stoney people are a sub-group of the Nakoda. The *Assinipwat*, or "Stone People," separated from their larger tribe near the Great Lakes in the 1600s. By the early 1700s, they lived in the foothills and the plains near the Rocky Mountains. The larger group of Stoney people divided into smaller groups called bands, which usually took the name of their original leaders. The town of Morley, Alberta, is currently home for the Stoney nation bands of Bearspaw, Chiniki and Wesley (formerly the Goodstoney).

In a 1901 article in the *Calgary Herald* newspaper, journalist Elizabeth Parker, who was also one of the founders of the Alpine Club of Canada, writes about the Stoney Nakoda:

> The Stonies, like all hill tribes, are independent and unconquerable, fierce fighters and mighty hunters, possessing great physical courage and stoical endurance, qualities which men admire, and which characterize all great peoples. They are true highlanders winning courage from the perils of the fords and precipices, difficult trails and strenuous weather of the mountains, where roam the big game by which they live.

CHIEF DAN WILDMAN

Over the years, Catharine and her mother were active letter-writers, and much of their correspondence is now in the Whyte Museum of the Canadian Rockies Archives. The letters document Catharine's

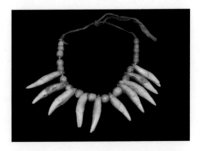

Necklace of grizzly bear teeth and beads, strung on a thong of buckskin

daily life, such as interactions with friends, including one of her and Peter's Stoney friends, Chief Dan Wildman.

Peter and Catharine Whyte purchased this necklace from Chief Wildman when they were painting his portrait in October 1930.

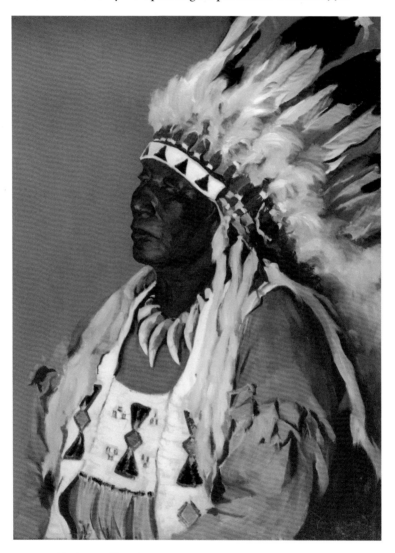

Chief Dan Wildman wearing necklace made of grizzly bear teeth, 1930,
Catharine Robb Whyte, oil on canvas

In a letter to her mother on October 19, 1930, Catharine writes:

He said, Do you want that? He came back with an eagle hat and all his beadwork, but best of all a necklace of grizzly teeth and he showed us by waving his arms about how he had shot the bear, three times in the side, last time in the mouth, which is one of the best ways to shoot grizzlies. Their skulls are so thick you can't penetrate them.

On October 21, 1930, Catharine adds:

Dan wears a necklace of grizzly teeth from bears he and his brother-in-law shot and he told us a white man offered him three dollars this summer but he wouldn't part with it. I loved it, so Pete asked him how much he would sell it for and he said, to us three dollars, so we have it.

There is another likely connection to this artifact in ethnographer Marius Barbeau's *Indian Days on the Western Prairies* (1960). In Barbeau's account, Chief Dan Wildman tells the story, "Bear Hunting," in which he refers to a hunt with his brother-in-law:

Excerpt from Catharine Robb Whyte's letters to her mother – October 21, 1930

We were moving into the mountains for hunting one summer, with my brother named Broken Elbow, *Ispaksahan*. We hunted in the valley of the Kinbasket River. One morning in the Berry month (August), I heard a woman talking, excited. It was about a grizzly. I got up at once, no clothes on. I took my gun, just ran out. I saw a bear running away from the camp, the biggest bear I ever seen in my lifetime. We made a charge at the bear. We shot him. The bear turned around. I don't know how many times we fired at him. He would turn around, and just bite himself. My brother-in-law said, "Let us get as near as we can. I know our bullets don't get through the body." We charged as close as we dared. I went side to side with my brother-in-law. And my brother went a bit ahead of us, and we stopped. We could not get any farther. The bear was sitting against a tree and watching us. We got as close as we could, banging him on the head. My brother shot at him too. Finally we killed him, and we stripped him and found I don't know how many bullets in him. He had been wounded by other hunters before. And this bear had many bullets in him. He had an awfully bad smell. So we found out that it was a man-killer and we threw it away. We just kept the hide.

Medicine woman Corleigh Belton listened to the "Bear Hunting" story and added:

It's been said that if you go out bear hunting, grizzly bear hunting especially, make sure you kill it the first time you see it, 'cause if you wound it, it will be out for revenge. And it knows you; it can smell your scent, so I'm wondering if there were a couple of old wounds in there that festered. And when they came across it, he was just so angry, and so when they shot at it, it wasn't even fazed.[5]

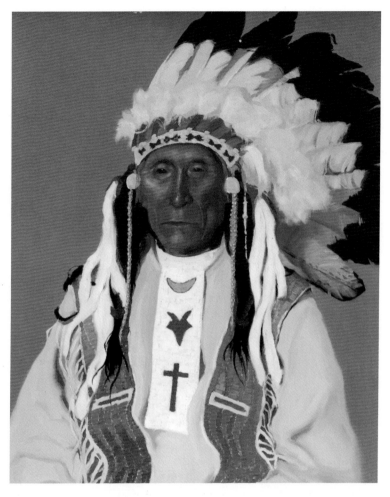

Chief Hector Crawler (Calf Child), 1931, Peter Whyte, oil on canvas

CHIEF HECTOR CRAWLER (CALF CHILD) AND
CHIEF GEORGE McLEAN (WALKING BUFFALO)

There are many stories of First Nations people hunting bears. Repeatedly, they portray the grizzly bear as an animal that merits serious consideration. Hector Crawler and George McLean were both prominent Stoney leaders whose hunting stories reflect the Stoneys' relationship with bears.

Hector Crawler (Calf Child) was a respected chief (1922 – 1933) and a medicine man of the Stoney Nation. Long after his death, his reputation as a skilled hunter carries on. Many of his trophies grace the walls of museums around the world. Horses from his herd were familiar sights at exhibitions, rodeos and racetracks throughout Alberta. He died in 1933, after being gored by a bull.

Walking Buffalo, *Tatânga Mânî* or George McLean (1871 – 1967), was Chief of the Stoney First Nations Bearspaw Band from 1920 to 1935, a political leader and a philosopher. Walking Buffalo was affected

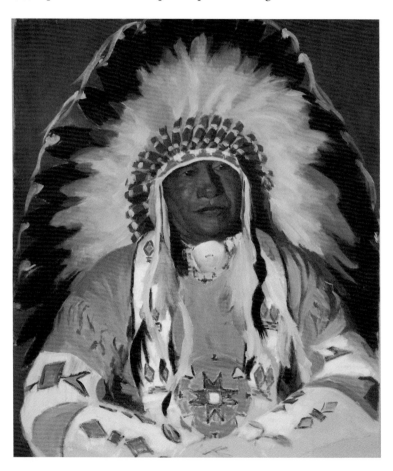

Chief Walking Buffalo (George McLean), c1930s, Peter Whyte, oil on canvas

by many changes throughout his lifetime, such as the acceptance of Treaty No. 7, signed between the First Nations of what is now Southern Alberta and representatives of the British Crown in 1877. The treaty document outlined how First Nations and the rest of Canada were going to get along; how land was to be allocated and used; and how those who lived on the land should be compensated for giving up the rights to it. A written document, Treaty No. 7 is still part of Canadian law.

Attracted to the Moral Rearmament movement in 1934, George McLean became an ambassador for world peace. Estimated to have travelled 200,000 kilometres (125,000 miles) internationally by the age of 87, Walking Buffalo spread the message to "stop hating each other and start being brothers the way the Great Spirit intended."

George McLean (Walking Buffalo) tells a story that relates one of Hector Crawler's (Calf Child's) adventures just before the coming of the railway in the 1870s:

When Hector Crawler was young, he was a great hunter and trapper. He went trapping in the mountains on snowshoes every year in the spring. And I have followed him a couple of times. We packed our grub, maybe fifty pounds of flour on our backs, and our bedding. When camping time would come, he would hunt where there was shelter of trees and not too much sun, because up in the mountains there was five or ten feet of snow. We used to cut boughs off the trees for bedding on top of the snow and then make a fire. Crawler took all these trips.

One day in the summer, just below the place now called Banff, where the CPR crosses the Bow River, there was a bear on the other side of the Bow River. Another man with Crawler was *Gahimangku* (Crow's-Breast). He told him, "Let us go and play with the bear!" It was a big grizzly. They had guns with them. But they just wanted

to make fun, and let it be known that they were capable and brave enough to tackle a grizzly with one gun. They stripped off their clothes. Hector had a big knife, one of these big Hudson's Bay knives. He put that knife behind his back, into his belt. But *Gahimangku* had no knife. Just as they were doing this, the bear came into the river. They went into the river too, also to meet him. And just as they got in the middle of the river, they met the bear swimming and got on each side of it. When the bear wanted to grab at one man, the other would grab the bear and turn him, while swimming. They played with him like that until they had floated maybe half a mile down stream. The river became shallow. There they could swim no longer. But the bear could swim. Then Crawler took his knife and thrust it into its side. He gave the knife to his friend, who did the same. And they let the bear go. It floated along and died. And they got it to shore. And then they skinned it and took the meat. This is the story of these hunters, of what they did to the bear. [6]

Cree First Nations

DALE AUGER

Although most of the artifacts in the Whyte Museum's collection are from the Stoney people, the Museum holds artworks from other First Nations, including Cree. The Cree are the largest group of First Nations in Canada, with over 200,000 members and 135 registered bands. The term "Cree" most likely originated from a French name of unknown origin. There are many branches of the Cree nation spread across the country. Originally, they were woodland people and spoke the Algonquian language of Eastern Canada.

Big Bear Medicine, 1998, Dale Auger, acrylic on canvas

Dale Auger (1958 – 2008) was of Sakaw Cree descent, from the Bigstone Cree Nation in Northern Alberta. The strong connection between people and animals is clear in Dale Auger's portrayal of the grizzly bear.[7]

Author Joseph Boyden, in *Three Day Road* (2005), further illustrates the importance of the bear to the Cree people. In the novel, an old Cree medicine woman tells a vivid story from when she was a girl:

> The following afternoon my mother and father prepared the bear for us. Normally we did our butchering outside, but the bear was our brother, and so he was invited in. Nothing was rushed. Nothing was to be wasted for fear of angering him. The knife used couldn't touch anything else. Any of the hair that the bear shed was carefully collected from the floor and clothing, and burned in the fire, whispered prayers drifting up with the stinking smoke . . . Then he and my mother cut along the inside of the bear's legs and gently peeled the fur from his body, cutting carefully where they had to separate flesh from fur, until the animal hung there naked. He looked like a small, thin man dangling from his feet, blood dripping from his head. For the first time I realized why we were told the bear was our brother.[8]

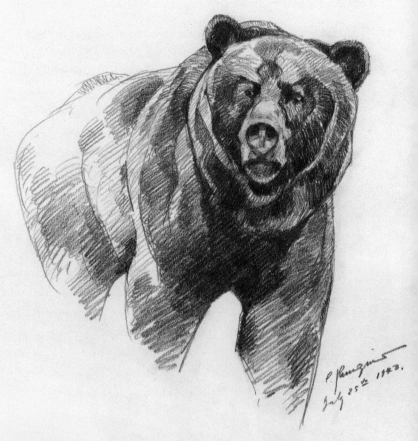

My early preoccupation with the thrills of hunting the occasional cattle killer and my twenty odd years experience as a professional big-game guide gave way to realization that here was a truly great and wonderful animal far different from what we supposed. I wanted to know him better ... So I dropped my rifle and picked up the pen and the camera to see what could be done to save some of the fast-vanishing wilderness and thus to help the grizzly that must have it to survive.

Andy Russell, *Grizzly Country*, 1967

Bear Sketch, July 25, 1943, Carl Rungius, pencil on paper

In Pursuit of the Wild

There are many ways of interacting with bears. The following stories convey the impact on humans following a range of encounters with these wild creatures. If we have never hunted, it may be difficult to understand the thrill of pursuing and killing wild animals. However, many people hunt for pleasure and will be able to relate directly to the experiences of Jimmy Simpson and Carl Rungius in the Rocky Mountains. Others will relate to the artists who capture only images. Some of us will find that visiting a zoo or a natural history museum may be our sole opportunity to observe bears.

Outfitters, Hunters and Artists

For a period starting in the 1920s, wildlife illustrations for hunting magazines were the bread-and-butter work for many artists. This type of work was a significant source of income for artists such as Carl Rungius, Clarence Tillenius and R.H. Palenske. While some of these illustrations depict sensational encounters with bears, others show serene mountain scenes. Hunting guides such as Jimmy Simpson led both hunters and artists in their pursuit of the wild.

JIMMY SIMPSON AND CARL RUNGIUS

In an undated newspaper article entitled "Out on the Deep, Soft Snow," Jimmy Simpson – a legendary Rocky Mountain guide and out-fitter – provides an insight into the views of hunters as he describes the thrill of the hunt.

> Visualize this: A clear, cold morning in early May, with the first rays of the sun bursting on the higher peaks. Snow frozen hard enough to dispense with snowshoes, but before long it will soften, and travel for the day will be over. The sun peeps through a break in the ranges and floods the valley with a soft, warm light, but

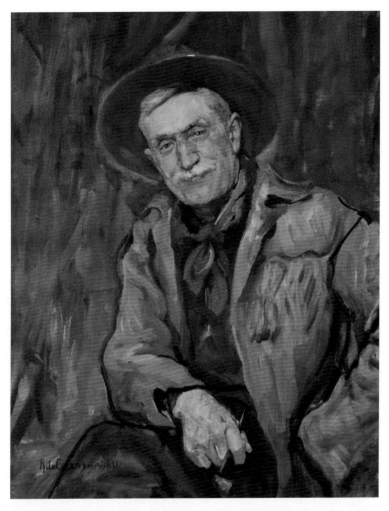

Jimmy Simpson, guide and outfitter for Carl Rungius, Nicholas de Grandmaison, oil on canvas

the open water of the clear spring creek calls a halt to look for a crossing, dry shod. A fallen log forms a bridge, but before it can be reached the willows part and a large grizzly walks into the open. He shakes himself and you see over the rifle sights the sheen of his long, silky coat. The wind is right and he has not seen you, but as the discharge echoes, and re-echoes it does not drown the savage roar of the stricken animal. He plunges headlong toward

40

you, unconscious of your presence, but of that you are not aware. Something tickles up and down your spine and your very hair roots fill with motion. You hear him splash in the open creek and stand, every muscle tense, awaiting his reappearance. It seems like hours – it is but seconds. Then you see him lying motionless in the clear cold water, a trailing line of crimson winding slowly past. Gingerly you approach, but there is no need for care, only strength, strength to pull the huge bulk to the gravel beach, where the final chapter may be written with the hunting knife. And through it all the robins sing and the chipmunks play, oblivious that another tragedy in their world of tragedies has happened.

The article ends: "This is a fair sample of a spring bear hunt. It may sound hard. It is. It may sound foolish, but is it? It has its compensations and pleasures. Were life-giving health the sole reward it would

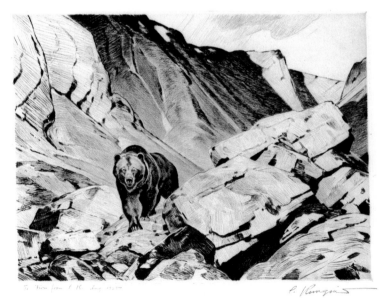

Old Bald Face, 1935, Carl Rungius, etching on paper

be full or worth it, but the memories that will never fade are yours and yours alone."

Jimmy Simpson (1877 – 1972) played a large part in enticing wildlife artist Carl Rungius (1869 – 1959) to the Canadian Rockies. Although Carl Rungius is best known for his wildlife art, he came to the Rocky Mountains not just to paint, but also to hunt. The story of how the two men came to know each other began with Jimmy Simpson receiving regular *Bulletin* newsletters as a member of the New York Zoological Society. From there, it happened like this:

"On one of his infrequent trips home from the trap line, [Jimmy Simpson] picked up the *Bulletin* with his mail and began leafing through it. He possessed a keen eye for art, and was struck by the reproduction of Rungius's painting, both because of its subject matter and because of the professional way in which it had been portrayed. With typical zeal, he immediately sat down and wrote a

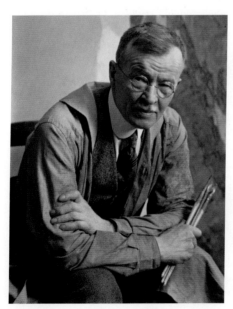

Wildlife artist Carl Rungius, inscribed 'To Pearl and Phil Moore with affectionate regards.'

letter to Rungius, care of the Society, indicating his admiration for the artist's work and offering him services for free if he would come to the Rockies and paint bighorns. A skeptical Rungius read the letter and then crumpled it up and threw it away, muttering to his wife Louise that it was just another guide looking for another client. Her interest piqued, she

pulled it out of the trash, read it, and detecting the fine hand of an educated man, convinced her husband that it was a serious offer that should be accepted."[9]

Carl Rungius and his wife, Louise, stayed with the Simpson family until 1922, when they built a studio and home – known as "The Paintbox" – on Cave Avenue in Banff, Alberta. Rungius spent nearly 50 summers in the Banff area between 1910 and 1959. He returned to New York for the long win-

The Family, April 1937, Carl Rungius, etching on paper

ters. Throughout much of Rungius's time in the Canadian Rockies, Jimmy continued to outfit his summer pack trips.

Ted (E.J.) Hart's book *Jimmy Simpson, Legend of the Rockies* recounts the following story of Carl Rungius hunting a grizzly bear:

On the way up we noticed fresh bear sign and reaching the top of the pass I saw a large grizzly just disappearing behind a little hill about a mile ahead. The outfit halted and Simpson said, "Get busy!" Jerking the rifle from my saddle I started in the direction of the bear.

When I reached the general locality I saw a gopher sitting up on top of a little hill, intently watching something on the other side. From this I knew that the bear was near. But I was not prepared for what followed.

I stalked carefully up the hill, when suddenly a black fox rose up directly in front of me; he was stalking the gopher! The black fox is always a rarity, in the wild state, and this was a beautiful animal so the temptation to take him was great. But I wanted the bear, so I passed up the fox. When I reached the top there was the grizzly,

walking broadside to me, not over 50 feet away.

My shot through the shoulder paralyzed him, he fell with his back in a hole he had been digging and never rose again, but sat upright grabbing his hind legs with his front paws and biting

Carl Rungius sketching a bear

at them. Jim said he could hear the bear roaring; but I was so intent on getting the grizzly that I never noticed it. I finished off the animal . . .

As he most often did, Rungius completed some sketches of the grizzly before the party proceeded on its way.[10]

CLARENCE TILLENIUS

Clarence Tillenius, born in Manitoba in 1913, developed an early interest in drawing wildlife. He sold his first magazine cover to the *Country Guide* in 1934. Despite the loss of his painting arm in a construction accident in 1936, Tillenius persisted in pursuing a career in art. After studying art in

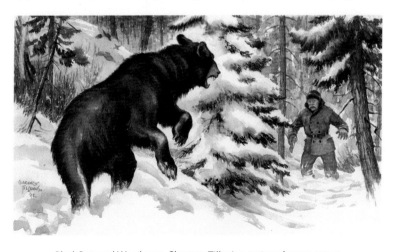

Black Bear and Woodsman, Clarence Tillenius, watercolour on paper

Winnipeg, he sought out Carl Rungius for further instruction. Tillenius received commissions for magazine covers and illustrations, with publication across Canada and the United States. Another significant achievement was his Monarch Life Assurance commission to paint the "Monarchs of the Canadian Wilds," which he undertook in 1954. He completed this series of paintings over a period of 30 years. In 2005, Clarence Tillenius painted "Pondering Grizzly" – the only grizzly bear painted out of sixty cement bears, each eight feet tall – as one of his contributions to a fundraising event for Cancer Care Manitoba. Clarence Tillenius is one of Canada's premier wildlife artists who has made a lasting contribution to the public's understanding and appreciation of wildlife.

R.H. PALENSKE

Reinhold H., or R.H., Palenske (1884 – 1954) was a graphic artist and painter. According to letters in the Whyte Museum files, R.H. Palenske was a "completely self-made man, son of poor Polish immigrants, born in Chicago and largely self-taught." Another friend recalls that he attended art school in Chicago and began his art career as a newspaper illustrator and lithographer. Palenske later worked at a Chicago advertising agency, eventually moving from graphic arts to administration. He first came to Western Canada with his assignment to the agency's advertising contract with

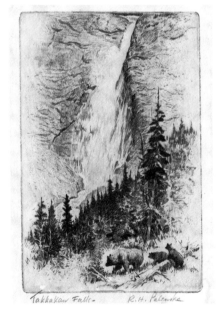

Takkakaw [sic] *Falls*, R.H. Palenske, etching on paper

45

R.H. Palenske, c1930s, in a Trail Riders of the Canadian Rockies camp

the Canadian Pacific Railway (CPR). In 1923, a trail ride with John Murray Gibbon, the chief publicist with CPR, led to the formation of the Order of the Trail Riders of the Canadian Rockies, a group supported by the Canadian Pacific Railway to help tourists explore the Canadian Rockies on horseback. Palenske frequently participated in the group's annual trail rides to different parts of the Canadian Rockies. Today, Palenske's work is in the Library of Congress, the New York Public Library and the Royal Gallery of London, England.

CHARLIE BEIL

Charles A. (Charlie) Beil (1894 – 1976) also portrayed bears in some of his artwork. Beil was born in Germany in 1894. After coming to North America in the 1920s, he worked as a muleskinner and cowboy. He was a self-taught artist who was influenced by the great western artist Charlie Russell. While working on a guest ranch in Montana in the 1930s, Beil met the influential Brewster family of Banff, with whom he would continue to have a close relationship for the rest of his life. He moved to Banff in 1934 and established a studio producing murals,

dioramas and bronze sculptures. Beil was a contemporary and neighbour of Carl Rungius on Cave Avenue in Banff. Probably the most well known of Beil's sculptures are the rodeo trophies he produced for the Calgary Stampede. Charlie Beil lived in Banff for over forty years and remained active as an artist until his death in 1976.

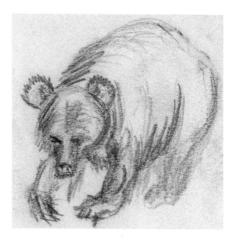

Bear sketch, excerpt from page of sketchbook, Charles A. Beil, c1930, pencil on paper

Both Beil's sketches and his sculptures reveal his ability to capture the character and movement of his subjects. Too often grizzlies are portrayed as ferocious beasts, but in the sculpture shown here, Charlie Beil has captured an alert and observant bear.

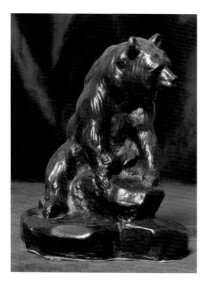

Grizzly Bear, Charles A. Beil, Bronze

Charlie Beil working in his Banff studio

A glimpse of Banff home decorating in the early 20th century at the Moore Home

Trophy Bears

As tourism increased, visitors sought souvenirs of their experiences in the Rocky Mountains. Individuals ventured into the mountains to experience, hunt and collect. While some people collected sketches or photographs, others collected tangible reminders of a different kind. Undoubtedly, all took souvenirs of the wilderness home with them in one form or another. For hunters, the form was usually that of animal trophies. Many people, even those who did not hunt, decorated their homes with game heads on their walls and rugs made from hides.

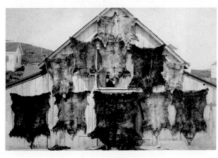

Bear hides on Barn, Jumping Pound, Alberta

48

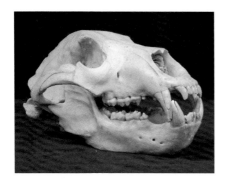

The skull of a grizzly bear that was killed by Stoney First Nations people

Peter and Catharine Whyte, the Museum's founders, once had a bearskin rug in their home made from the pelt of the same grizzly whose skull is pictured here. It was the fashion of the place and time.

With tourism ever increasing, so did the demand for refined ways to experience many of the park's wonders without danger. Created in response to this demand, the Banff Park Museum was the first museum in the national parks to exhibit mounted specimens of resident plants, birds and animals. The collection was actively maintained and expanded from 1896 to 1932. Today, the museum houses more than 5,000 specimens that are characteristic of early museum practices. Still in its 1903 location, the historical significance of the Banff Park Museum makes it a "museum of a museum."

NORMAN LUXTON

The demand for ways to explore the bounty of the park in a safe and certain environment continued to lend itself to the creation of other museums, also exhibiting taxidermy specimens

Postcard of taxidermy black bear with cubs on display at the Luxton Museum

of the local wildlife. Norman Luxton (1876 – 1962), founder of what is now the Buffalo Nations Luxton Museum, describes how the museum came to be:

In 1952, in my old age, I realized my lifelong dream of creating the Luxton Museum of the Plains Indian. I had been collecting Indian relics and natural history specimens for 50 years, and through the generosity of my old hunting buddy, Eric Harvie, I secured the financial backing I needed to expand my collection and build a museum to house and display it. Sculptor Ron Spickett built lifelike Indian mannequins, and cowboy artist Charlie Beil designed a diorama of the Buffalo Jump. The museum acquaints visitors with the way of life carried on by those who roamed the plains, mountain vastnesses and coastal areas for centuries.

The taxidermy grizzly bear on display at the Luxton Museum continues to awe visitors with his size and formidable claws. In the film *Jimmy Simpson: Mountain Man* (1996), Jimmy tells his story of hunting this bear:

> I never had any trouble with bears . . . In fact, I should have been killed. I broke the hip of a very large grizzly – the one that's in Luxton's (Museum), that stands up like that, ya know. He went through more than a foot of snow up to the edge of the timber. I followed

Postcard of taxidermy grizzly bear on display at the Luxton Museum

him right through some heavy willows and didn't know if he was behind any willow or not. And I got within 50 feet of him and there he was, standing looking at me. I should have been killed – the fact was I couldn't move in the snow. Lucky, lucky. No, I never had a particle of trouble!

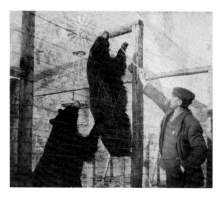

Black Bears at Banff Animal Paddock

Captured, not Killed

Not all hunts ended in the death of the animals. Many guides and outfitters of the Rocky Mountains supplemented their income by providing live specimens for the Banff Zoo.

THE BANFF ZOO (1908 – 1937)

Why was there a zoo in a national park where the wild is all around? In the early 1900s, Banff business owners and the federal government knew that wildlife was a big attraction for tourists to the newly created Rocky Mountains Park. However, the only way to ensure that the wealthy, educated visitors would be guaranteed of seeing bears in the park was to create a zoo to contain them.

As early as 1897, an animal paddock was built to protect a few surviving examples of the near-extinct plains bison. Annual reports (1907, 1913) from Canada's Department of the Interior help to trace the developmental steps of the Banff Zoo. The Buffalo Paddock, as it became known, eventually kept live specimens of most wild mammals found in Rocky Mountains Park. The Paddock was popular, but the national park's Commissioner Howard Douglas thought it was unsanitary. When the Town of Banff installed sewage and running water, Douglas took the opportunity to recommend that the government establish a zoological garden (zoo) on the grounds behind the Banff Park Museum, in what is now Banff's Central Park. The zoo began with an aviary populated by eight donated pheasants, which were a popular attraction. Adding to the appeal of the Banff Park Museum, tourists could now view live wildlife in comfort and safety.

By 1908, the Banff Zoo had permanent, iron-barred cages and the animals from the Paddock moved in. The cages featured cement floors

to keep them sanitary, and sulphur rock walls for a rustic appearance. By today's standards, the zoo was primitive. In their time, authorities considered the cages superior to all others of their size on the continent. The fact that the cages appeased human needs over the needs of the animals is a reflection of wildlife management in the early 1900s. In 1908, one black bear, a brown bear and a cinnamon bear were amongst the 26 animals transferred from the Buffalo Paddock to the new zoo. The following year, the Department of Interior's Annual Report stated that all of the animals transferred were "in perfectly healthy condition and are fat and sleepy, and appear to take to their comfortable new quarters kindly."

Under the direction of Commissioner Douglas, the zoo expanded over the next three years to eventually also include non-indigenous animals, such as rhesus monkeys. In 1912, the park's new

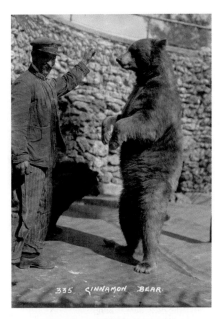

Zookeeper feeding bear at Banff Zoo

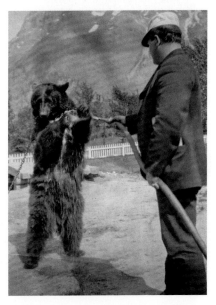

Captive black bear being washed with a hose at the Sanitarium Hotel, Banff, Alberta

Pat, the Polar Bear in Banff Zoo

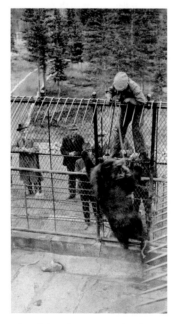

Grizzly bear being manipulated with rope at Banff Zoo

Superintendent, A.B. Macdonald, purchased two grizzly bear cubs for the zoo. The following year, they exchanged two moose for a polar bear named Pat. It did not seem important to visitors that polar bears are not native to the area, so Pat was a big attraction.

The Banff Zoo thrived from 1908 to 1937, but the Great Depression brought ever decreasing operating funds. In 1937, the animals were rehoused at other zoos and the zoo closed. The history of the Banff Zoo illustrates how the need to make Banff and Rocky Mountains Park a major tourist attraction overshadowed the importance of preserving wildlife in their habitat. While zoos today continue to be a tourist attraction in many places other than Banff, they now play an important role in conservation. Although attitudes toward wildlife have changed in the past century, the pursuit of the wild still affects wildlife and their habitats.

Hunting in the national parks has been illegal since 1909. However, it is still legal to hunt grizzly bears in some parts of Canada. For instance, Alberta only suspended the grizzly hunt in 2006, after scientists and environmentalists reported that the bears'

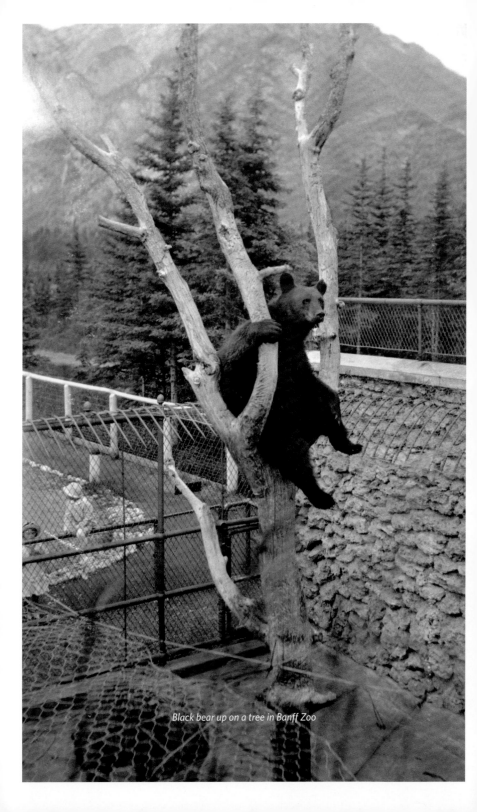

Black bear up on a tree in Banff Zoo

survival in that province was in peril. It is also legal to hunt black bears in many jurisdictions in the Canadian Rockies. Some wildlife managers claim that hunting black bears decreases bear aggression and makes them more likely to avoid human settlements; there is no scientific evidence to support this claim.[11] Hunting has not historically posed a threat to black bear populations, but this situation may be changing. If bear populations are to remain viable, many conservationists believe that hunting must stop. Unfortunately, experts estimate that for every bear shot legally by a hunter, poachers kill two. Neither the British Columbia nor the Alberta governments are making moves to further protect black bears in their native habitat.

Yet bears are made of the same dust as we, and breathe the same winds and drink of the same waters. A bear's days are warmed by the same sun, his dwellings are overdomed by the same blue sky, and his life turns and ebbs with heart-pulsings like ours and was poured from the same fountain.

John Muir, 1871

Bear cub discussion

Souvenirs

Throughout the past century, postcards and other media have had dramatic influences on our attitudes. From harmless entertainment to cute and cuddly clowns, images from the past send us a message about how our relationship with bears has developed to their detriment.

Harmless Entertainment

Like many visitors to the Canadian Rockies today, visitors of the past hungered for authentic souvenirs. Bear heads or hides made outstanding gifts and keepsakes. A photo of you with a chained bear was a spectacular memento of your visit. Apparently without much consideration for the bears, many locals and visitors took advantage of any opportunity to capitalize on, or claim their own part of, the wilds of Canada.

Well before he founded what is now the Buffalo Nations Luxton Museum, Banff entrepreneur Norman Luxton opened his Sign of the Goat Curio Store in 1903. Referred to alternatively as a store, shop or post, the Sign of the Goat sold a range of wilderness "souvenirs." To draw customers' interest, he kept a live bear chained just outside the store's entrance. Ironically, the adorable bear outside the store was actually luring customers in to purchase real animal hides and stuffed specimens. Although bears provided artistic inspiration for some and invoked a sense of the wild for others, they were sometimes seen as harmless entertainment.

In 1903, I opened the Sign of the Goat Trading Post. I made it look like a museum so that people would be interested, even if they didn't always buy. A few years later, we reopened on the other side of the river, where it stands to this day. In 1927, I renamed it Banff's Indian

Trading Store. With my brother, Lou, managing the store, we shipped furs, big-game heads, Indian beadwork and relics of all kinds everywhere in the world to royalty, millionaires, hunters and tourists.

I used to keep a pet bear chained to the front of the store, a sure drawing card for eastern city-slickers looking for a piece of the Wild West . . ."

Norman Luxton

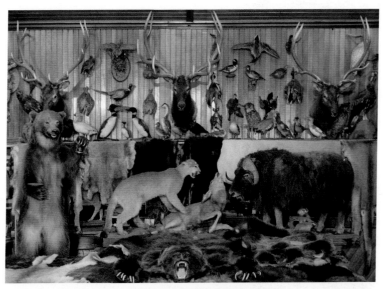

Inside Sign of the Goat Curio Store

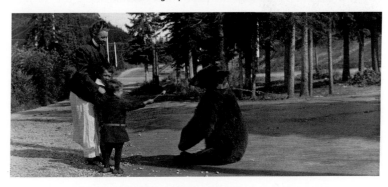

Mrs. Scarth with Monty, Kathleen and Norman Luxton's bear

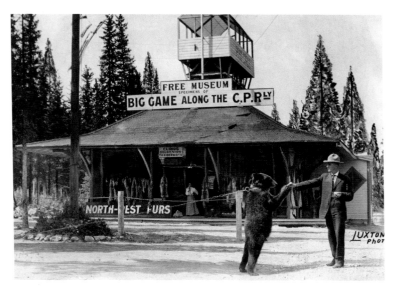

Louis Luxton (Norman's brother) feeding pet bear in front of Sign of the Goat Trading Store

Captive bear cub at Luxton Trading Post

In the early part of the 20th century, Luxton was not the only one who chained bears for entertainment. From Mount Robson to Field, BC, bears were a source of amusement.

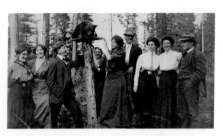

Big group posing beside bear cub chained to a pole

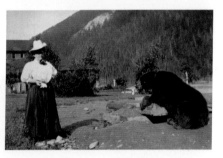

J.W. Beatty and Curly's (Phillips)
cub by Mount Robson

Mrs. Frank Freeborn and black bear at
Mt. Stephen House, Field, B.C.

Cute and Cuddly

As children, many of us went to bed cuddling our teddy bears. We might have arisen to Saturday morning cartoons featuring wacky Yogi Bear taunting Ranger Smith in Jellystone National Park. Or, perhaps we enjoyed a Walt Disney television show featuring cute little bear cubs roaming innocently through beautiful landscapes. Occasionally they found an empty cabin, but only to make a big and very funny mess. Later, Care Bears became all the rage in plush toys and cartoons. Then there is Canada's very own Jasper the Bear, the humorous, harmless

'Jasper, the bear' cartoon postcard

cartoon character featured on postcards throughout the Canadian Rockies in the 1950s and '60s.

Many of us also grew up listening to Winnie the Pooh bedtime stories, which have another Canadian connection. The author, A.A. Milne, named the character after a teddy bear owned by his son, Christopher Robin Milne. Christopher had named his toy bear after Winnie, an American black bear he once saw at the London Zoo. Canadian Lieutenant Harry Colebourn was en route to England during the First World War when he purchased the bear cub, Winnie, from a hunter for $20 in White River, Ontario. Colebourn named the bear "Winnie" after his hometown of Winnipeg, Manitoba. Secretly brought to England with her owner, Winnie gained unofficial recognition as The Fort Garry Horse regimental mascot. The bear eventually ended up in the London Zoo.

Unfortunately, the types of teddy bear images conjured up by Disney, Jasper the Bear or Winnie the Pooh create attitudes and expectations that are not based in reality.

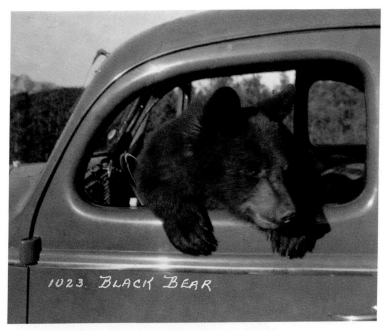

Bear in a car

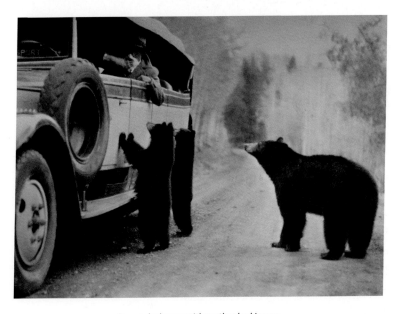

Bear cubs by car with mother looking on

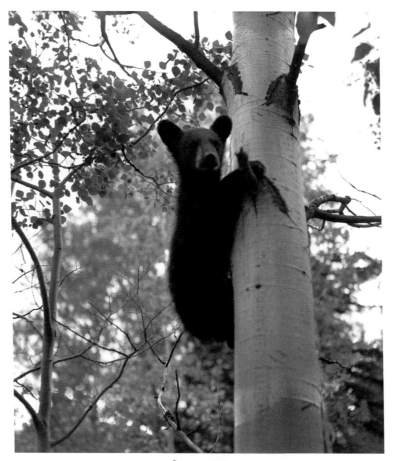

Bear up a tree

Postcards from the Past

Postcards are an amazing visual record of attitudes toward bears in the Canadian Rocky Mountains. The Whyte Museum recently catalogued a collection of postcards from Banff, Lake Louise, Jasper and other famous mountain locations. Many of these souvenir postcards feature bears, even though most people do not actually see a live bear during their visit.

(930) A BEAR IN THE CANADIAN ROCKY MOUNTAINS.

Postcard, c1929

The text on the back of this postcard accurately communicates the 1929 perspective of bears that may still exist to some extent in the present day.

Thousands of square miles in the Cana-
dian Rockies add up to one of the largest
game sanctuaries in the world. Banff
National Park, famous for the summer
resorts of Banff and Lake Louise, is noted
for the many fine trophies secured by
enthusiasts who hunt with cameras.

Natural clowns, bears provide fun for
the onlooker. During tourist season, they
are often met on the highways and, parti-
cularly if they are part-grown, seem to
show off to an audience. Their good-
natured antics frequently lead to begging
for sweet-stuffs. Their supplications are
hard to resist but park wardens advise
you not to feed them as they are short-
sighted and unaware of their own
strength.

This picture, made after the season
closed, is unusual. When there are many
people about, bears seem to prefer the
mountain highways—perhaps they like
to watch the cars go by.

(The picture is of Lake Louise and, in
the background, Victoria Glacier).

ADDRESS

Message in

FOLKARD COMPANY OF CANADA LIN
CANADA, COPYRIGHT CAN

TO OPEN FOLD AND TEAR OFF

Text on back of postcard of bear in the Canadian Rocky Mountains, c1929

Ultimately, this view of bears led to problems. Supervising Warden
C.V. Phillips of Jasper National Park recounts (1944) a cautionary tale
about the danger of human interaction with bears:

> During the summer of 1943 there was born to one of the black bears
> who frequented the townsite of Jasper four cubs, three brown and
> one black. This was quite an unusual occurrence and needless to say
> was quite an attraction not only to the travelling public but also to
> the inhabitants of Jasper.

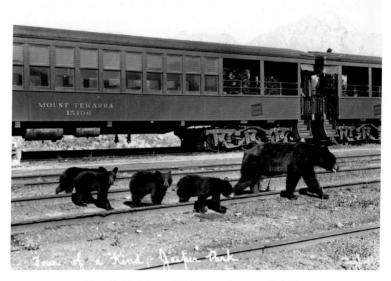

'Four of a Kind, Jasper Park' postcard, c1940s, likely the
same cubs as in Warden Phillips's tale

For some time after they were born the mother kept them away
from town, but a stealthy visit during the night revealed an abun-
dance of food, of sorts, in garbage cans.

From then on these cute little "clowns of the forest" were
doomed. They quickly became used to human beings, who went
out of their way to become "friends" of the cubs. Countless choco-
late bars, biscuits and other tidbits were fed to them in the process.
Hundreds of feet of film were exposed showing the public feeding
the cubs in various poses, even to picturing children rolling on the
grass with the cubs.

The immediate outcome of this contact with human beings
resulted in the bears demanding the contents of any bag or parcel
being carried by people shopping for themselves. Complaints
against this practice were almost a daily occurrence at the [Parks]
Administration Building.

A passenger from a train standing in the station who had just
bought supplies from one of the Jasper stores was backed up against

the store window by a mother bear and the supplies were released without question.

The bear was not vicious but who could tell what would have happened if this person had resisted the demands of the bear. After all, these bears are wild animals with a lot of wild ancestry behind them and their apparent tameness is only a thin veneer.

In the summer of 1944, these cute little cubs of 1943 will have lost their cub attractiveness but not their liking for garbage cans and the chocolate bars of the superior animal. As soon as there is a shortage of this questionable feed, basements will be raided and there will be a call for the warden's bullet to end the life of this cute little cub of 1943.

This is the ultimate result of these unfortunate creatures contact with "friendly" but unthinking human beings.

Bears are fascinating animals that capture our imaginations. However, our perceptions of bears as friendly, entertaining jesters have bolstered false impressions of how we should interact with these dynamic creatures. Ultimately, the death of many bears that have become a "nuisance" is essentially the fault of inappropriate human behaviour.

A Bear of a Traffic Cop at Johnson's Canyon [sic] near Banff, Alberta

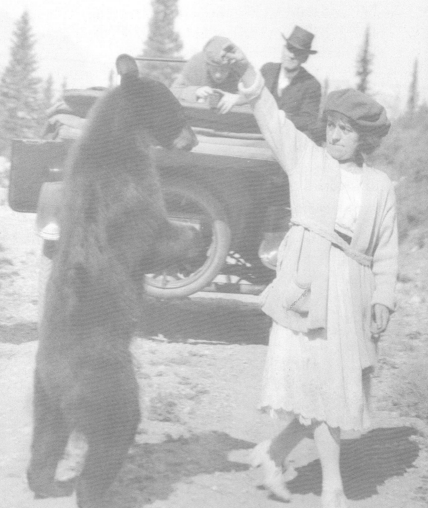

Bears are not noted for their driving skill and this one made no effort to control the vehicle.

Banff Crag and Canyon, June 2, 1976

Elsie Brooks feeding a bear

The Evolution of the "Bear Problem"

Human contact with bears increased with the building of the Canadian Pacific Railway, but that was only the beginning. Roads came next, carving even more paths into the Canadian wilds. As roads blasted through the mountains, they destroyed many natural barriers between people and bears, sometimes leading to conflict.

Fed, not Feared

The development of roads through the Rockies threw the doors open for bears to start appreciating meals on wheels. The first automobile arrived in Rocky Mountains Park in 1911. More than any other technology, the automobile changed the way visitors experience the park. Demands for roads and services increased access to wilderness areas. Without proper understanding, the resulting contact between bears and humans created many problems.

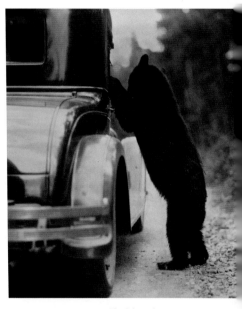

Black bear by car

Although it happens less today, traffic still often grinds to a halt when someone spots wildlife. As wildlife specialist Kevin Van Tighem states, "People in a crowd do things they would never dream of doing alone, and bear jams often produce incredibly bizarre human behaviour." He adds, however, "Surprisingly few serious attacks occur at bear jams – black bears are remarkably tolerant of stupidity."[12]

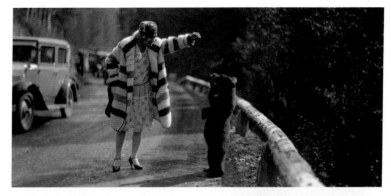

Woman in Hudson's Bay blanket coat feeding a black bear cub

Three Canadian icons: the Royal Canadian Mounted Police, the Hudson's Bay blanket coat, and an icon of the wilderness, the bear.

These images demonstrate the cavalier attitude of motorists toward bears. Throughout the years, the *Banff Crag and Canyon* newspaper has printed many articles about roadside bears, or bruins as they were commonly referred to in folklore, fables and local newspapers.

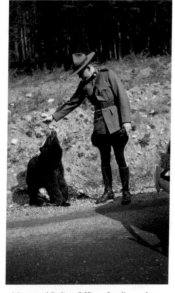

Mounted Police Officer feeding a bear before it was illegal to do so

"ROADSIDE 'ANIMAL ACT' STAR TOURIST ATTRACTION"

Banff Crag and Canyon July 1, 1959

One of the greatest "animal acts" seen here in many years is currently providing a sensational, super-colossal and generally good show for visitors and residents alike.

The act – consisting of a mother bear and her triplet cubs – is on view along the Trans-Canada Highway or Minnewanka Road every

Postcard of black bear and cubs, Byron Harmon Photos, Banff, Canada

day as the bruin family wanders over landscape in search of food, good fun and maybe even a gawk at tourists.

The mother is a large brown bear and her cubs (one black, one brown and one almost a honey colour) are as cute as it is bearishly possible to be, standing on their hind feet, romping around their mother and sometimes climbing up on her back. Mama Bear seems to be quite friendly with motorists . . . so far.

Several visitors driving Alberta cars were seen Sunday night to stop, get out of their automobiles and feed the bear and her cubs. Up to now, none of these foolish types have been struck down by the mother, whose seemingly placid attitude toward humans is given the lie by a rather sharp-looking set of teeth and an equally dangerous complement of claws. . .

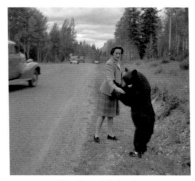

Dancing with destiny

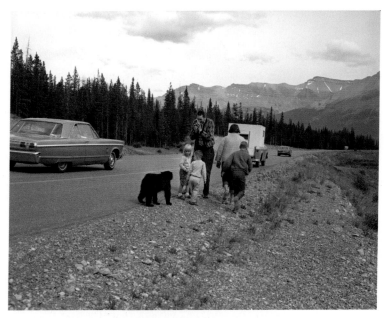

Cub following family with children

"MAN FEEDS BEARS - BEAR STEALS CAR"

Banff Crag and Canyon, June 2, 1976

A peculiar incident occurred near Saskatchewan Crossing on the Banff Jasper Highway on the evening of Sunday, May 23. It would appear that a motorist and his wife stopped at the edge of the road to get a better look at a black bear. The motorist de-

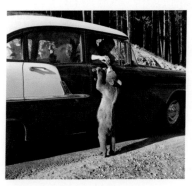

Bear cub being fed by person in a car

cided to get out of his vehicle, a foolish move at the best of times, and he walked around the back of his car leaving his wife inside it.

The bear, meanwhile, had padded his way stealthily around the passenger side to the front of the car. Having made it around to the driver's

side, and espying the open door, the bear decided to investigate the car's interior.

The motorist's wife, seeing the bear's intent made a hasty exit from her door and evidently frightened the animal or at least confused him for he became agitated in the close confines of the vehicle and inadvertently brushed against the gearshift lever.

The motor was running and the bear's action caused the car to roll off the road, much to the surprise of the motorist, who had to this point been wondering where the bear he had spotted had gone.

Bears are not noted for their driving skill and this one made no effort to control the vehicle. It is to be supposed that raw terror was the chief emotion running through his mind as [he] tried to figure a safe way out of the situation in which he now found himself. The car did not go far, though, before a convenient ditch interposed itself in its path and brought it to a halt. The bear made a speedy exit and the motorist and his wife got their car back, a little worse for wear.

Although it still refers to bears as a problem, this article is one of the first in the *Banff Crag and Canyon* to warn people not to mess with bears, no matter how cuddly they appear. It is no surprise that all of this roadside feeding eventually led to problems.

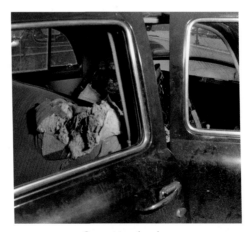

Car seat torn by a bear

For the bears, these problems sadly resulted in death.

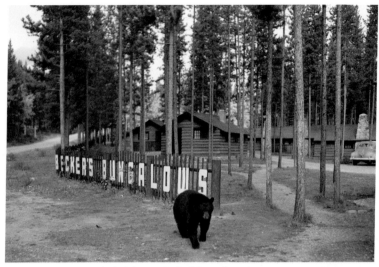

Black bear at Becker's Bungalows, Jasper

AUTOMOBILE BUNGALOWS

The roads brought other temptations for wildlife. Automobile bungalow camps sprang up throughout the national parks, adding additional temptations for wildlife. Many bears have paid visits to camps such as Johnston Canyon in Banff National Park and Becker's Bungalows in Jasper National Park.

Canada's National Parks Bureau was increasingly aware of concerns regarding bears attacking humans. In response to a 1944 memo from head office, Prince Albert National Park's Superintendent Herbert Knight cites shack tents and auto bungalow cabins as factors contributing to the "bear nuisance":

SHACK TENTS AND AUTO BUNGALOW CABINS: It is usual to have under the shack tent or cabin a small box for keeping provisions cool and more often than not the box is placed in a shallow hole dug just under the outside of the shack tent or cabin. These small storage boxes are frequently raided by bear and it is surprising how soon they get to know the purpose of boxes so placed under buildings. The

proper solution to the above is for the owners to have small concrete boxes in which to keep provisions cool.

Roadside access to food has contributed to endless bear deaths on highways and railways throughout the Rocky Mountains. Yet, transportation routes are not the only factor contributing to bear mortality.

TOWNSITES AND CAMPSITES

Bear holding a mug

Visitors and townspeople intentionally fed nice little bears. Campers carelessly left food around camp and picnic sites. Bear-proof containers are now *de rigueur* and there are no longer garbage dumps in the national parks. In the past, however, garbage cans and nuisance grounds (garbage dumps) provided a buffet of accessible foodstuffs for wild animals. Together, all of these occurrences perpetuated the so-called bear problem.

Wardens were the people responsible for dealing with human – bear relations. Day or night at any hour, problems that arose usually ended with a call to the warden. Walter Peyto (1884 – 1963) moved to Banff in 1900 and was in the warden service from 1914 – 1948. In the 1950s, Warden Peyto told this story to amateur Banff historian Mabel Brinkley:

> At any hour of the night the phone would ring and a scared voice would say, "Oh warden, there is a bear at my door."
>
> Of course, the sympathetic warden would have to go into the night and chase the intruder away. If that procedure did not meet the bear's approval and he got argumentative, a charge of coarse salt from a shotgun sent the bear slithering through the bush. But if it still wanted to win the argument, sterner tactics had to be taken. That

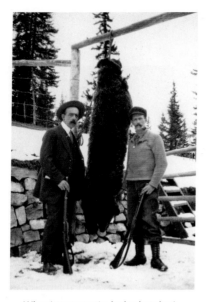

When 'sterner tactics had to be taken' – Jack Warren and Walter Peyto with dead bear

depended upon the temper of the bear and also of the warden who had just been wakened from a restful slumber. Usually, however, Bruin chose to be cooperative, but there is no more unpredictable animal than a bear.

One lady had been putting food out for a 'nice little bear,' and feeling overly kind one evening, she spread honey on a board and put it out for his sweet little taste buds to absorb. That night at about two thirty a.m. my phone rang. From her hysterical description I guessed that she had all the bears in Banff National Park at her back door, and some of them were pretty argumentative. I told her to reach out and take the board before I got there. Needless to say she did not take any more honey out for any 'nice little bear,' but she did put an extra lock and hook on her back door.

Newspaper articles from the *Banff Crag and Canyon* tell of many occasions when bears lost their lives in the early part of the 20th century. All of the stories involve food left in accessible locations. To contemporary sensibilities, some of these articles are at times difficult to read due to their rather bloodthirsty quality.

"GRIZZLIES LAID LOW"
Banff Crag and Canyon, June 8, 1918

Three large grizzly bears were shot down and captured in one night by Chief Game Warden H.E. Sibbald and his assistant

J.R. Warren in the vicinity of Spray Lakes. The warden had been called out as a result of complaints made by the inspector of fish hatcheries to the effect that bears were molesting the traps used to catch fish spawning . . . The first night they saw four of them where they were throwing out suckers in piles around the creek. This was attracting the bears . . . Another reason why it was necessary to do away with these grizzlies is the fact that the fishing season is to start shortly when they would prove a great nuisance and perhaps dangerous to the fisherman . . .

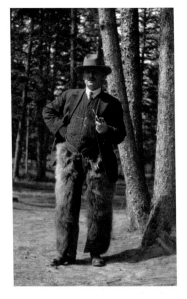

Howard Sibbald, first chief park warden in the Canadian national parks (Note the grizzly-bear chaps)

"WARDENS KILL BIG GRIZZLY BEAR NORTH OF LAKE LOUISE: HAD BEEN MAKING FREQUENT RAIDS ON CAMP 7 – TRAILED SEVEN MILES THROUGH SNOW"

Banff Crag and Canyon, October 21, 1932

A very fine specimen of a grizzly bear was killed Monday last by Wardens LaCasse and Bennett, in the vicinity of the construction work being carried out on the Lake Louise–Jasper highway. The bear measured eight feet long. He was an old fellow as shown by his teeth, which were very badly worn down.

This big grizzly had made several raids on Camp 7 during the past few weeks and on Saturday night last paid another visit. Warden Bennett happened to be at the camp that night and took a shot in the dark at the big fellow and managed to crease him across the top of the neck, but this fact was not known until after he had been killed. On Sunday night despite the wound he had received the previous

night, the bear paid another visit and his regular visits decided the department that the animal must be killed as there was too much danger in having him running at large endangering anyone who might come close to him . . .

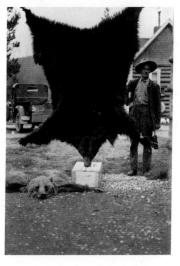

Warden Ulysses LaCasse with bearskin

"HEAD JAMMED INSIDE MILK CAN, BEAR HAD TO BE DESTROYED"

Banff Crag and Canyon, October 8, 1943

"Thirsty" was written Sunday morning for a year-old black bear at the rear of Union Milk premises here after bruin had spent an exhausting night with its head firmly caught in an 8-gallon milk can.

Mr. Sam Redfern, manager of the milk company's branch, heard considerable noise in the back yard Saturday evening, but being used to similar rackets from the action of mischievous bears, paid little attention until it became prolonged; he then went out but failed to see the bear, although he could hear the noise at the end of the lot. A second time he went out and planned to arm himself with a big stick which he kept handy, but the club had been removed, so he decided to let events take their course.

Early Sunday morning the noise awakened Mr. Redfern and then he discovered the bear's plight. He immediately got in touch with Game Warden Walter Peyto, who with assistance and some ropes tried to free the animal but to no avail. Finally the bear had to be shot to put the unfortunate animal out of its misery for it was completely exhausted after its ordeal.

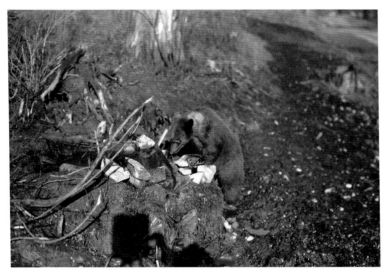

Bear raiding a picnic

In addition to Superintendent Knight's 1944 *Shack Tents and Auto Bungalow Cabins* note, he also cites more causes of the "bear nuisance" in his response to Parks' head office:

CARELESS AND UNTIDY CAMPERS: Campers who leave their camp with provisions lying around, and not burying their garbage, empty cans, parings, waste bread, etc., are offenders, for it is by their desultory actions that bear are encouraged to visit camps for food and to damage the tent to obtain food stored within.

GARBAGE CANS: So long as we have garbage cans we will have the bear nuisance and the only hope is that a proper sewerage system will be put into effect as soon as possible after the war and then the use of garbage cans will only be required for ashes, etc.

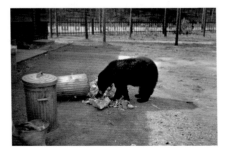

Bear rifling through garbage cans

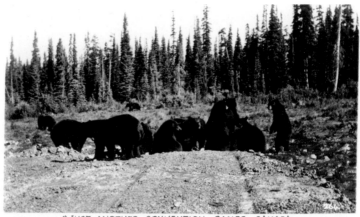

Postcard of bears at Lake Louise dump, c1930

Garbage Dump Observation

Garbage dumps not only provided easy food for bears, but also became popular tourist attractions as action-packed places to observe wildlife. Many onlookers did not realize that during this time humans had a three-strike policy for bears. Each time they captured a bear, they marked its haunches with red paint. On the third offence, the bear was shot.

"Brace of Bruin Triplets Entertain Visitors"
Banff Crag and Canyon, August 23, 1961

Two mother bears, each with sets of triplets, are currently regaling visitors to the dump.

One of the mothers looks suspiciously like the critter that had triplets two years ago and put them through their paces for the entertainment of visitors travelling the highway below the Timberline Hotel. If it's the same one, she has produced three of a kind this time in contrast to her progeny of 1959 which consisted of a black, a brown, and a honey-coloured cub.

At the dump last night, the two sets of triplets and their mothers were joined by a big black bear, doubtless the proud papa of the brood.

The dump (and Banff may be the only town on the continent which includes its dump among its tourist attractions) swarms with visitors these nights as the bears come in for dinner. Last night, some of the cubs could be seen washing each other's faces to the delight of onlookers.

It's a sobering thought, however, to contemplate the future that awaits these cute little fellers should they get the idea they'll always be welcome around tourists. Little do they know their future is rosy in one respect only . . . red paint on their bottoms if they keep hanging around here after they've grown up.

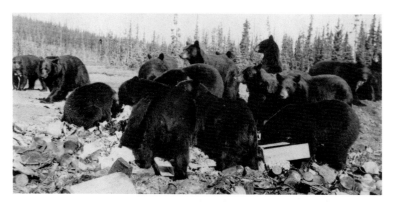

Crowd of black bears at the Banff dump

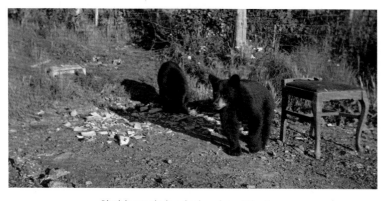

Black bear cubs by a broken chair at the dump

What becomes increasingly clear is that a range of human activity – from poor food and garbage management, to the intrusion of transportation routes interfering with wildlife corridors – has created the "bear problem."

Solutions to the Bear Problem?

A memorandum sent out January 28, 1944, asked park superintendents throughout Western Canada to submit stories about bears. Responses to the memorandum included those from superintendents like Herbert Knight as well as those from park wardens. Wardens not only reported first-hand incidents, but also provided some very practical advice about avoiding bear attacks. It took over 35 years for the national parks to implement the wardens' advice regarding food and garbage management.

Although wardens with immediate experience dealing with bears suggested viable solutions, bears continued to die. Supervising Warden J.C. Holroyd of Waterton Lakes National Park nicely summarizes the 1944 situation:

> In my opinion the best way to eliminate the bear nuisance in campgrounds etc., is to remove the cause, which of course is food left where the bear can get at it. Garbage should be collected oftener, campers' supplies kept in bear-proof boxes and any bear that persists in being a nuisance should be shot.

In another response to the memo, Warden J.M. Giddie of Jasper National Park writes several observations about why bear attacks occur. He also suggests some ways to avoid problems with bears:

> All bears are not looking for trouble, and the majority go away at the first sign of a traveller encroaching on its domain in its wild state. This applies particularly to grizzly. The female with cubs are particularly dangerous, never get between the mother

and her cubs, either for the purpose of getting snapshots or for other reasons.

Never feed a bear around camp, and see that all supplies left in camp when everyone is away are hung at least 8 to 10 feet above ground. (A rope thrown over a limb of a tree, supplies tied to one end and then drawn up to the desired height is the usual method). If a bear visits camp, in practically all cases, he does not wind (smell) the supplies.

In the case of the ordinary black bear frequenting the camp grounds of the National Parks and tourists suffering injuries from these animals, it is usually caused, perhaps not by the individual, but by some members of the public feeding or molesting them.

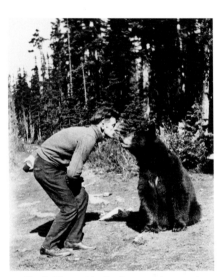

Charlie Maynard feeding bear mouth to mouth

A few attack stories submitted in response to the 1944 memorandum were incidents that involved a mother bear apparently protecting one or more of her cubs. The vast majority of the encounters point toward human behaviour as the primary issue: feeding bears, getting too close trying to photograph them or leaving garbage in inappropriate places. Regardless of fault, wardens had the unpleasant duty of shooting most of the unfortunate bears painted as repeat offenders.

In an effort to avoid killing bears, the 1940s saw translocation rise to become the initial response to a problem bear. Translocation involves

A bear trap, 1941

trapping and relocating a bear to another area. Although repeatedly shown to be an ineffective solution, many places outside of Canada's national parks still relocate bears.

"'RUMBLE SEAT RED' USED ON TOO-CHUMMY BEARS"
Banff Crag and Canyon, July 27, 1960

The House of Commons, which hears reports from cabinet ministers every so often as to their conduct of Canadian affairs, last week learned from Resources Minister Alvin Hamilton that bears' derrières are being painted red in an effort to cope with what is termed the "bear menace" in Canada's National Parks – mainly Banff and Jasper.

This is the procedure. When a bear is seen to become too friendly with tourists, he is captured in the familiar bear barrel. At some time or other during his stay in this contraption, he has one of his haunches painted red by means of a long-handled brush, and is then taken for a ride to one of the far reaches of the park and released.

If he comes back to the settled portions of the park, he is captured again and has the OTHER side of his rumble seat decorated. He is once again given a ride to the hills back yonder.

If he is a persistent type and comes back to civilization a third time, he is dispatched to the bear's happy hunting ground.

So far this year, 20 bears have left this world after a third offence. Last year, 75 bruins met an untimely end.

In the Commons last week, Mr. Hamilton suggested that tourists seeing the red-bedecked bears would do well to take warning and keep clear.

Bow River MP Eldon Woolliams suggested tourists be allowed to carry firearms, but failed to find support from Mr. Hamilton.

The same edition of the *Banff Crag and Canyon* ran this hoax ad:

MALE HELP WANTED

SOBER. industrious man urgently required to paint rear end of bears. Must be member of painter's union. Apply Box 23, Crag & Canyon. 30

The following week, a headline read: "Enthusiastic Response Greets CRAG Ad Seeking Tinters of Park Bears' Posteriors."

The article notes that written replies and telephone calls in response to the ad started pouring into the office soon after the paper came out. The responses were hilarious, with comments from applicants such as: "My bear bottoms are the talk of the trade," or, "I am not very bright, but I am sober and have exceptionally long arms, which should be an advantage in this kind of job." And a final note asked, "P.S. Does it take very long for bear scars to heal over?"

Translocation was a solution to the bear problem in Canada's national parks for more than 60 years. Although the goal is to prevent further nuisances and mortality, it is not an effective solution. Many bears simply find their way back

Wardens tie up a bear's snout, 1971

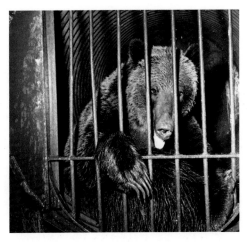

Grizzly bear captured in trap

home because they cannot adapt, or they run into problems with locally established bears in new areas. Others die at the hands of hunters outside the national park boundaries. In a 1999 report on translocation, prepared by Mike Gibeau and Robin Munro for Parks Canada, the conclusion states: "the preliminary results from the West Slopes Study provide some of the strongest evidence to date that translocation as a management practice, at least in many areas, is doubtful at best and unethical at worst."

Safely relocating a bear is a difficult task. Once a bear has learned to associate humans with food, it is likely that the bear will seek out more humans in the new location. As Van Tighem writes, "Moving a bear creates an illusion that you've solved the problem and saved a bear, but often the bear simply dies later."[13] To illustrate this sad fact, a headline in the October 1, 2009, issue of a Canmore, Alberta, newspaper, the *Rocky Mountain Outlook*, reads, "Relocated Bow Valley Grizzly Shot in BC." The bear had been relocated a distance of 990 kilometres (615 miles) from the Bow Valley near Banff and Canmore to Fort St. John, BC. The RCMP shot and killed the 3½-year-old grizzly bear because he came into the town of Fort St. John.

Unfortunately, national parks' wardens have had to kill multiple offending bears. Shooting bears did not always go smoothly for the warden assigned the task. Warden J.M. Giddie of Jasper National Park wrote this story in the 1940s:

At Glacier Park a bear (black) broke into Morris' store and did considerable damage; it left but returned the following day. It was considered necessary to destroy the animal and a warden shot it. The bear staggered to an opening and fell mortally wounded. It was watched for a considerable time and no movement was noted so it was considered dead. The warden then walked up to it without his gun and turned it over, to his surprise the bear reared, struck at him and severely tore his arm and side necessitating a long trip in hospital.

This goes to prove the Oldtimers statement "that having shot a bear either black or grizzly give him another and smoke a couple of pipes of tobacco previous to approaching him to skin, but be good and sure that the animal is dead."

The *Banff Crag and Canyon* reports that in 1959, 75 bruins were shot in Banff and Jasper national parks. From 1950 – 1980, it is reported that 523 bears were killed and 547 were relocated.[14]

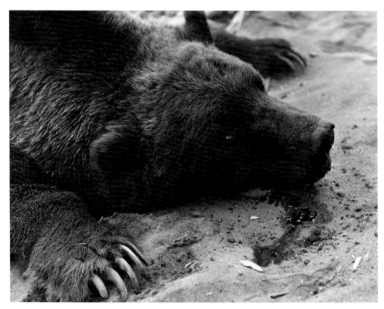

The sad end

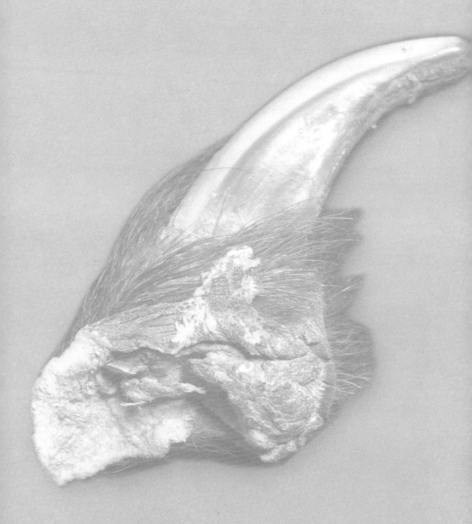

"Never argue the right of way with a grizzly if you are unarmed."
Warden J.M. Giddie, 1944

Grizzly bear claw (actual size)

Attacks and Near Misses

The idea of a bear attack evokes primeval fear in most people. As sharks are to the ocean, bears are to the mountains. Although attacks are rare, many of us have a macabre attraction to such tales. One of the best-known books on the topic, *Bear Attacks: Their Causes and Avoidance*, by Dr. Stephen Herrero, has sold over 87,000 copies. First published in 1983 and revised in 2003, Herrero's book includes well-researched and frightening tales of real bear attacks. As professor emeritus of environmental science at the University of Calgary, Dr. Herrero's professional practice focuses on mammalian carnivore ecology and conservation, often with particular attention to bears. During his career, Herrero has been an adviser after many of the attacks that have taken place in the Canadian Rockies, including some of the cases reported here.

The following attack stories begin with an entry from the journal of 18th-century explorer David Thompson (1770 – 1857). It is the first written account of an attack in this area. Fast-forwarding to the late 1930s, Nick Morant's grizzly attack story could not be left out; it is local legend. Wardens are amongst the few individuals who interact with bears as part of their jobs, so some their stories have also been included. Finally, the 1980 attacks at Whiskey Creek near the Banff townsite are briefly reported here, as they sparked significant changes to how we deal with bear – human interaction in the national parks.

The First Bear Attack Story Ever Written in the Canadian Rockies, 1787

First Nations storytelling is an oral tradition rather than a written one. Consequently, the first bear attack story ever written down in this area is from *David Thompson's Narrative*. Thompson wrote the

narrative based on detailed journals of his experiences as an explorer, fur trader, surveyor and mapmaker from 1784 to 1812. During his career, Thompson mapped over 3.9 million square kilometres of North America. This 1787 story involves Piikani First Nations, near the present site of Calgary, Alberta.

A few days after our arrival, the death cry was given, and the Men all started out of the Tents, and our old tent mate with his gun in his hand. The cry was from a young man who held his Bow and Arrows, and showed one of his thighs torn by a grizzled bear, and which had killed two of his own companions. The old Man called for his powder horn and shot bag, and seeing the priming of his gun in good order, he set off with the young man for the Bear, which was at a short distance, they found him devouring one of the dead, the moment he saw them he sat up on his hind legs, showing them his teeth and long clawed paws. In this, his usual position, to defend his prey, his head is a bad mark, but his breast offers a direct mark to the heart, through which the old man sent his ball, and killed him. The two young men who were destroyed by the Bear, had each, two iron shod Arrows, and the camp being near, they attacked the Bear for his skin and claws, but unfortunately their arrows stuck in the bones of his ribs, and only irritated him; he sprung on the first and with one of his dreadful fore paws tore out his bowels and three of his ribs; the second he seized in his paws, and almost crushed him to death, threw him down, when the third Indian, hearing their cries, came to their assistance and sent an arrow, which only wounded him in the neck for which the bear chased him, and slightly tore one of his thighs. The first poor fellow was still alive, and knew his parents, in whose arms he expired. The Bear, for the mischief he had done was condemned to be burnt to ashes, the claws of his fore paws,

very sharp and long, the young man wanted for a collar but it was not granted those that burned the Bear watched until nothing remained.

Nick Morant's Grizzly Attack

Nick Morant told this story to Peter and Catharine Whyte, who recorded it for their archives. It is excerpted from a conversation in 1950 between Nicholas (Nick) Morant, Ivy May "Willie" Morant (Nick's wife), Catharine Robb Whyte, Peter Whyte and two local boys (Tommy and Bill). The story is in his words, with only minor edits. The attack took place on September 19, 1939, at Sherbrooke Lake in Yoho National Park. Nick Morant, Canadian Pacific Railway photographer, and Christian Hasler, Swiss guide, were both seriously injured in the attack.

When Morant and Hasler first saw the grizzly bear that attacked them, they were not particularly concerned until they realized that it was a mother bear with her cub:

There was the mother grizzly coming for us, as hard as ever she could come. Boy was she travelling! So Hasler and I, we threw our rucksacks off with my camera equipment in it, and we ran as hard as ever we bloody well could. We jumped up into trees.

I looked back, and there was Hasler's legs disappearing up into the tree. And almost at the same time the grizzly appeared at the bottom of the tree. And she looked so small, you know, she didn't look like she'd ever be able to get him. His legs were way too high. But there I was wrong because I learned something there that I never realized before—that a bear's like a caterpillar. You know how a caterpillar suddenly gets bigger? Well the bear does the same thing. And she stood up and she took Hasler by the leg at nine feet off the ground. And she ... ripped him right out of the tree just like somebody had hit him on the head with an axe. She jumped on him, started to

tear at him just like a wild creature, for that's what she was, after all. And poor Hasler was crying for help and here was I sitting up a tree and I didn't know what to do. Now there's a real predicament. Would you stay up in the tree, or would you come down and try and help the other one?"

I came down out of the tree and came up behind the old grizzly and wacked it over the behind with a stick. So, she swung around and came at me, and I started to run . . . But I remembered that a grizzly can run awfully fast. They can overtake a horse in an open field . . . So I threw myself on the ground so that the bear wouldn't have a chance to strike at me with her claws. And then when she rushed at me I kicked her in the face with my big boots. Well . . . she got very mad, and she was just as quick as lightning. She grabbed me by the leg with her mouth

So I beat at her with my fists to try and make her let go . . . she let go . . . and grabbed me by the arm . . . Now just as quickly as she attacked me, she went back after Hasler [who] had been mauled very badly. And anybody who tells you, if you play dead the grizzly won't bother you—they're crazy as hell, you can tell them for me. 'Cause that grizzly went right back and started to maul Hasler again . . . and having mauled Hasler again, she came back looking for me. She grabs me in the upper part of the right arm above the elbow and she just shakes me like a rat. She threw me probably ten or fifteen feet.

Now while the second attack was happening, Christian Hasler regained consciousness and he realized that there was nothing that he could do. He was very badly wounded [but] he made a run for it and he got away. And he alternately ran and walked and fell unconscious at least eight times, all the way back to Wapta Lake from above Sherbrooke Lake . . .

The bear . . . makes a rush for me again. She runs across and comes right at my face, so I roll over and turn my face down into the rocks. And she bit me all over my body. She stepped on me once

and it was just like having somebody putting a grand piano on you. Terrible weight!

And I looked up, and there was the cub—it had come down off the mountain side. Just as she comes at me the fourth time the cub lets out a little yelping noise. And she turns around and she goes off down the trail with the cub. The cub saved my life.

By this time, Morant had a broken leg and a broken arm. He did not know that Hasler had escaped so he decided to go find help. After climbing 2000 vertical feet up the side of Mt. Ogden and circling back to Sherbrooke Lake so as not to encounter the bear again, he ran into his rescuers. He finished his story by saying: "That is probably the only instance of somebody who attacked – barehanded – a grizzly and lived to tell about it."[15]

Nick Morant in his studio
"Now I've always believed that if you leave the animals alone, they'll leave you alone. And it's still true—they will. With the exception, perhaps, of the grizzly, which is very unpredictable."

Wardens' Stories

Killing problem bears is often seen as the only solution to ensure that they do not attack or kill again. Four years after the bear attack on Nick Morant and Christian Hasler, the same bear allegedly chased Warden Horsey and his son. Wardens organized a number of hunts but were unsuccessful in killing the female grizzly bear and her cub. Other hunts were more successful.

G.F. Horsey, Acting Superintendent of Yoho National Park, wrote on February 4, 1944:

On July 8th, 1943, about four years after the above-mentioned incident, I was attac(k)ed by what is believed to be the same grizzly [that attacked Nick Morant and Christian Hasler] on the trail to Twin Falls at a point of approximately one and a half miles north of Takakkaw Falls in the Little Yoho Valley, which is only over the ridge from the Sherbrook (sic) Lake district.

My experience with the grizzly was as follows:

My son and I were walking along the Twin Falls trail in the Yoho Valley about one and a half miles north of Takakkaw Falls when he happened to turn around and immediately called my attention to two bears, one a large dark animal and the other a lighter coloured, much smaller bear, some three hundred yards behind, which were following us up at a rapid pace along the trail we had just come over. We stopped for a moment but as they kept on coming toward us, we started to run away from them along the trail. Every few seconds I looked back but found the larger bear, which I now realized was a female grizzly, was gaining on us. Apparently soon after the chase started, the cub left the trail and went into the bush as I saw no sign of it after the first time I looked back. When possibly the grizzly was within one hundred feet of us and I saw it was only a matter of a few seconds when she would overtake us, I hurriedly told my son to get off the trail into the bush and try to climb a tree. At the same time I flopped

down on the ground right across the trail, hoping to keep the bear's attention on me and away from my son. As I was lying flat on the ground, the bear came up, took one nip at my leg, put his paw on my right knee for only a moment, and then turned around and left, making for the bush on the opposite side of the trail from where my son had gone.

Wardens are more likely to have contact with bears than most other people are. Yet, a bear has only killed one warden in the past 100 years of warden service in the mountain parks. This fact is particularly remarkable considering the era of warden districts (1910 – 1970), when wardens lived in the remote areas of the park for which they were responsible.

On October 7, 1929, Superintendent Knight of Jasper Park reported the tragic story of Warden Goodair to the commissioner of the National Parks of Canada. Knight's matter-of-fact report gives a sense not only of the diverse roles of wardens in the early days, but also of the isolation that was a way of life for district wardens. His report follows:

Re: Late Warden Goodair – Jasper

The Supervising Warden spoke to Warden Goodair over the 'phone on September 10th, at which time he reported that one of his horses that had been lame had fully recovered and was again fit for service. As Goodair was not in the habit of reporting by phone frequently, unless matters of importance were to be discussed, the Chief Warden was not alarmed at not hearing from him for a week or ten days. When Warden Goodair was in Jasper at the month end he informed Mr. Langford that sometime during the month of September he intended on making a trip to the head of the Whirlpool river by way of Geikie Meadows and the Fraser River, in order to explore the country with a view of ascertaining the accessibility of the Park from the Fraser River side. It was his intention to enter the Park again

by way of the middle Whirlpool. When he had not been heard from for a week or ten days the matter was reported to me and it was considered he had gone on his exploration trip. However, after another two or three days, Warden Nelles was sent to the Tonquin Valley to investigate. He reported that everything indicated that Goodair had left the cabin temporarily, as his saddle and equipment were all there. Upon receiving this report, Mr. Langford and two other wardens left immediately to make further investigations. On September 26th, the body of Warden Goodair was found about one-third of a mile from his cabin at a point on a footpath near where he had been getting out firewood.

I went to the Tonquin Valley in company with the Coroner (Dr. Thos. O'Hagen) and Inspector Frere and viewed the remains where they were found. It would appear that he was in the act of getting out firewood when attacked by a grizzly bear, as his saw was laying beside [the] footpath and the axe was found nearby. Two small poles had already been cut and pushed over some wind falls toward the path, while a third pole had been prepared for carrying out. His hat was found under a spruce tree about 30 feet away from the dry poles and towards where he was found. It would appear that when the attack was made he dashed for the tree and there lost his hat. Numerous small limbs were broken off near the trunk of the tree, which indicates that he more or less fell against it when he lost his hat. No limbs were broken off the tree – just beyond the tree and while he was in a standing position as his neck was badly bruised on one side where possibly he had been hit. His chest was badly lacerated by two distinct scratch marks, and his side under the right arm was torn to such an extent that a main artery had been severed. It is thought that after the bear had left him he was able to walk a few yards to the footpath where he was found. Nearly a foot of snow had fallen after his untimely

death, and as a consequence no marks of the struggle could be seen, other than the broken branches where his hat was found. The bear with a cub was seen by the wardens about a mile from the cabin on September 27th. This is probably the same bear that attacked Warden Goodair.

Yours faithfully

(Signed) R.H. Knight, Superintendent Jasper Park

Other wardens recount encounters and near misses. Stories like these help us to understand how attacks, like the tragic one that killed Warden Goodair, unfold. It seems appropriate that this next incident, reported by Warden J.M. Giddie, occurred around Bear and Grizzly creeks.

This incident happened in Glacier Park (B.C.) in the summer of 1926. There was a fire at the head of Quartz Creek which necessitated a trip from Bear Creek up Grizzly Creek and over the summit to see if the fire could cross into Glacier Park.

I had another warden with me and on nearing the summit in perfectly open country, excepting small patches of scrub, we saw at a distance of approximately one-quarter mile a Grizzly with two cubs. She had apparently heard us and was coming to investigate, but first she decided to let her cubs remain, this did not appeal to them and we had a great view of how she accomplished this, she knocked them down but still they continued to follow, on her second trip back to them she really handled them rough and we could hear them crying and then they ran off in the direction she intended them to go.

It was now her intention to find out all about us and she come on the run, the last 100 yards was a narrow draw with scrub pine and when she ran into this we decided it was time to move, my partner retired down the mountain and I continued along the mountain at about the same level. (This was done at about 100 yds. in record time).

We did not see the bear again but on the soft ground late that afternoon I could see that the bear had come to the point at which we were standing and then turned back and rejoined her cubs. This bear in my opinion [was] undecided as to what we were, but as soon as she had winded us was satisfied, if we had held our ground I do not think there is the slightest doubt she would have attacked us.

Never argue the right of way with a grizzly if you are unarmed.

The Black Grizzly of Whiskey Creek

In 1980, there were three bear attacks at Whiskey Creek, very near the town of Banff, Alberta. The initial attack led to the death of a man who had been fishing with his two sons and a friend. Local newspapers understated the series of attacks, but they made bigger news once the first victim died. *The Black Grizzly of Whiskey Creek* (2009), by former park warden Sid Marty, is an excellent account of the attacks. At the time they occurred, no one knew that these attacks would be catalysts for change.

"Black Bear Hunted after Man Killed"
Calgary Herald, August 25, 1980

Park wardens and RCMP have mounted an intense search for the black bear that attacked and critically wounded a Calgary man Sunday. Ernest Cohoe, 38, was knocked to the ground and bitten in the face after he startled the animal at Whiskey Creek, a fishing spot on the edge of town.

Cohoe managed to walk to a nearby housing development and was taken first to local hospital and then flown to Calgary's Foothills Hospital for emergency surgery . . .

The attack led to a massive hunt for the offender. Witness reports indicated that the culprit was a black bear. Thus, a black bear first identified as the attacker was shot and killed, but the attacks continued.

"Two more mauled; earlier victim dies"
Calgary Herald, September 2, 1980

Park wardens are combing the back country near the Banff townsite again after the second serious bear attack in just over a week.

Two men were mauled in the Whiskey Creek area Monday evening in almost the exact spot as a Calgary fisherman was attacked eight days earlier.

Ernest Cohoe, 38 died Saturday in a Texas hospital of head injuries suffered in the Aug. 24 mauling. He had been transferred to medical facilities in the U.S. for extensive plastic surgery.

Different bears

Andreas Leuthold, 25, Banff garbage attendant, and Remy Toblar of Switzerland, in his 30s, were attacked Monday about 50 metres from the scene of the earlier mauling but park wardens were convinced that different bears were responsible for each attack.

The hiking and picnic areas on the north edge of Banff townsite were reopened Thursday after wardens shot a large black bear that they believed was responsible for the first attack.

The wardens did not know at the time that they had shot the wrong bear. Finally, they snared a very large, black-coloured grizzly bear, identified him as the perpetrator and killed him.

"Bear strikes for third time"
Calgary Herald, September 4, 1980

Park wardens this morning shot and killed a grizzly bear they think was responsible for three attacks on people near here during the last 10 days

Parks Canada spokesman Ken Preston said the bear, which weighed between 230 and 270 kilograms, was killed near where a man was badly mauled Wednesday night.

Herald photos by Michael Rankin

WARDEN WITH BLOOD-SOAKED CLOTH
... used by victim of attack

HITCH-HIKER CHRIS ALLEN FROM TORONTO
... flagged down passing motorist

Bear strikes for third time

By Bruce Patterson
(Herald Banff bureau)

BANFF — Park wardens this morning shot and killed a grizzly bear they think was responsible for three attacks on people near here during the last 10 days.

Parks Canada spokesman Ken Preston said the bear, which weighed between 230 and 270 kilograms, was killed near where a man was badly mauled Wednesday night.

The bear was caught in a snare laid by the search team overnight, Preston added.

"We don't want to jump to any conclusions that it is the right bear," he said Tests were planned to first measure the animal's paws and claws and then compare them with the injuries suffered by the mauling victim Wednesday.

Wardens, RCMP, and other Banff workers had mounted a massive campaign to capture the grizzly bear following the third attack near the townsite.

A man, aged about 20, whose name has been withheld, was attacked just after 5 p.m. Wednesday when he tried to cross through the thickly wooded area that has been closed since a bear attack two days earlier.

Park officials believe the same bear is responsible for all three attacks that have left one man dead, two seriously injured, and a fourth recovering from minor wounds.

Preston said the animal has attacked in one particular area and in the early evening in all three cases. The description of the bear in the latest attack also fits earlier descriptions. The tracks at the scene of the latest attack match those found at a trap set for the animal Tuesday night.

"The assumption had been that it's a black bear," said Preston. "We now believe a grizzly has been involved in all three attacks."

He said a bear that was shot a week ago after the fatal attack on Ernest Cohoe, 38, of Calgary matched the description, but he said a young grizzly would have a similar appearance.

Heard scream

The latest attack occurred just after 5 p.m. Wednesday when a man was crossing the wooded area between the townsite and the Trans-Canada Highway near the Mount Norquay access road.

Chris Allen, 19, of Toronto, was hitchhiking when he heard a scream for help, he told The Herald.

"He came up the road saying 'I was mauled by a bear. I'm hurt, I'm hurt.'

"He was drenched in blood. His scalp was torn. His arm was ripped open. I pulled my jacket over his head and flagged down a car.

"He said he was looking for the highway when he was attacked."

Armed guards

Park wardens and RCMP are investigating why the man was in the area that had been posted out-of-bounds. The victim reportedly said he knew there was a closure, but wasn't sure where the boundaries were.

Within minutes of the attack, park wardens called in reinforcements. The area had been surrounded by a surveillance crew to keep the animal in the area.

Other wardens were brought in to prevent the bear from breaking out of the one kilometre square site that had been cordoned off.

RCMP were brought in as well and armed guards were stationed around the area watching from the top of a freight train, the roof of the train station, and along roads circling the wet marsh on the north side of town.

In a final effort to flush the bear from hiding, a helicopter was used to fly over the terrain with armed wardens aboard in case the animal broke into a clearing.

Preston said there are many traps in the area and wardens would keep watch over the traps through the night. He added that a provincial game specialist had set several snares throughout the area with dead beavers as bait.

A team of specialists had been brought into the park Wednesday to study the scene of the attack and the possibilities that natural food supplies or garbage in the area were factors in the maulings.

See MAULING, Page A2

The bear was caught in a snare laid by the search team, Preston added.

"We don't want to jump to any conclusions that this is the right bear," he said. Tests were planned to first measure the bear's paws and claws and then compare them with the injuries suffered by the mauling victim Wednesday. Wardens, RCMP and other Banff workers had mounted a massive campaign to capture the grizzly bear following the third attack near the townsite.

A man, aged about 20, whose name had been withheld, was attacked just after 5:00 p.m. Wednesday as he tried to cross through the thickly wooded area that has been closed since a bear attack two days earlier . . .

"The assumption had been that it's a black bear," said Preston. "We now believe a grizzly has been involved in all three attacks."

Their belief proved to be true. A very large black male grizzly turned out to be the perpetrator of all three attacks. Happening so close to a town, these attacks prompted great improvements to the management of food and garbage in the national parks. Local newspapers began to carry headlines detailing the fines given to restaurants that did not comply with regulations. Parks Canada started to hire wardens who had training in bear management and/or degrees in biology, ecology or related fields. Experts, such as Dr. Stephen Herrero, were also called in to help plan for better long-term management of bear – human relations in the parks. Despite the mistakes made, the hard lessons led to changes that would save the lives of both bears and humans in the future.

CHAPTER SEVEN

The animal that impresses me most, the one I find myself liking more and more, is the grizzly. No sight encountered in the wilds is quite so stirring, as those massive, clawed tracks pressed into mud or snow. No sight is quite so impressive as that of the great bear stalking across some mountain slope with the fur of his silvery robe rippling over his mighty muscles. His is a dignity and power matched by no other in the North American wilderness. To share a mountain with him for a while is a privilege and an adventure like no other.

Andy Russell, *Grizzly Country*, 1967

Grizzlies #2, Icefield Parkway, Maureen Enns, acrylic, charcoal, paper, glue on paper

Feared, Revered and Protected

ANDY RUSSELL

Grizzly Country (1967), Andy Russell's groundbreaking book and film, did much to change attitudes toward the misunderstood grizzly bear. Russell (1915 - 2005) was born in Lethbridge, Alberta. He lived almost his entire life in the Canadian Rocky Mountains as a hunter, guide, outfitter, photographer and filmmaker. As a renowned conservationist, he described his education as "limited formal education, considerable Rocky Mountain variety." In 1961, Andy Russell and his sons, Dick and Charlie, journeyed through Alberta, British Columbia, the Yukon and Alaska to conduct fieldwork on grizzly bears and their habitat. After their first season in the field, guns were left behind in camp. Although he had been a hunter, Russell grew to believe that "hunting, as an art,

Three Bears, Peter Karsten, pencil on paper

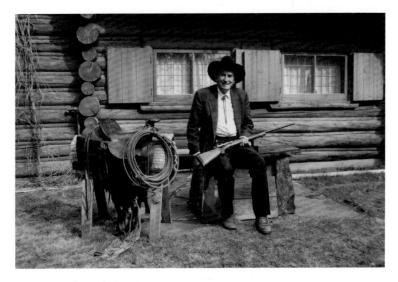

Andy Russell with some of his belongings donated to the Whyte Museum, 1994

can be refined to its highest degree through the medium of photography."[16] The Russells' fieldwork resulted in the book and film that began to shift long-held opinions of grizzly bears as killers. The Whyte Museum of the Canadian Rockies has extensive collections from both Andy Russell and his wife's family, the Riggalls.

Andy Russell's 1967 book awakened concern for grizzly bears and grizzly habitat, but for many years following this landmark publication, little changed. As detailed above, even in the mountain national parks the poor management of food and garbage continued to lead to conflict between bears and humans. Eventually, individuals like Eric Langshaw helped to build momentum for change. Warden Langshaw was the first to lay a charge against a major hotel for poor handling of food and garbage that was attracting bears.

ERIC (RICK) LANGSHAW

Eric Langshaw was the warden responsible for overall bear management in the Lake Louise district of Banff National Park. One night in the summer of 1979, he was called to the back entrance of

one of Lake Louise's finest hotels. The staff at this hotel had been repeatedly warned about storing trays of food scraps outdoors when they were cleaning up between banquets. A large male grizzly bear, attracted by the scraps, had been visiting the hotel repeatedly. Of course, hotel guests missed no chance to get in for close photos, and on this night, the bear was highly agitated by the time the wardens arrived. "When we got there, we discovered that one of the hotel security guards had actually been firing his little .38 revolver to try to scare the bear," said Langshaw. The wardens had no choice but to shoot the bear, for which they received significant abuse.

To stop this from happening in the future, Eric assembled a file containing the management history of the bear, and the warnings previously issued to the hotel. After consulting with an RCMP friend and being told he had a solid case, Langshaw served charges on the hotel. The manager laughed.

Upon returning from a four-day vacation, Langshaw was put on suspension for insubordination. The case went to trial and the hotel management was found guilty on all charges. They were fined and ordered to build a bear-proof garbage-storage facility. That legal decision made it clear that a liability for any bear incidents would reside with whoever allowed bears to get at poorly stored garbage. Langshaw was told he would be fired but managed to keep his job after the national media publicized his story. It was not long before Parks Canada began installing bear-proof garbage containers throughout the park.[17]

Langshaw's 1979 act of courage was the first official step in mitigating the bear problem in the mountain parks. However, it took the three Whiskey Creek bear attacks just north of Banff townsite in 1980 to send a "shockwave through Parks Canada" and spark further action on bear management. A necropsy was performed on the massive 10-year-old black grizzly that wardens eventually ensnared and confirmed to be the perpetrator

of the Whiskey Creek attacks. The examination revealed that the grizzly had been feeding on garbage for many years.

Following these 1980 attacks, Parks Canada made new plans for management that was more effective in reducing the harm caused to bears and humans. Some of the new protocols included the installation of bear-proof bins, approved commercial enclosures and the enforcement of garbage laws.

Despite improvements, the nine years from 1980 to 1989 saw human activity cause 91 per cent of the grizzly bear deaths in the mountain national parks. Natural and unknown causes were responsible for the other 9 per cent. The following 18 years, from 1990 to 2008, humans caused only 76 per cent of the 48 grizzly bear mortalities. It is encouraging that garbage caused only five deaths from 1990 to 2008, down from 17 deaths during the nine years before that period. Leading the causes of grizzly bear mortalities from 1990 – 2008 were railways (15 deaths) and highways (14 deaths). These figures represent the minimum known mortalities.[18]

Game underpasses and overpasses enable wildlife to safely cross the Trans-Canada Highway. Since the installation of these vegetation-laden bypasses, traffic on the Trans-Canada has killed significantly fewer bears. Yet, many highways in bear habitats remain without such mitigation measures, even within national parks.

The Canadian Pacific Railway (CPR) continues to be the primary cause of bear deaths throughout the mountain national parks. Grain spillage is a significant problem along the tracks. The CPR has stated that they are trying to deal with this problem, but it takes time. A December 2009 newspaper article reported:

> Since 2007 CPR has been working to fix faulty gates on 6,600 grain cars so they won't leak. More than 4,400 of the cars have been refurbished so far and it's possible the company will finish the job by the end of next year or early 2011 – years ahead of schedule. The price tag for the repairs is $20-million.

The company also uses a special rail vehicle to vacuum spills along the line, says Breanne Feigel, a CPR spokeswoman.

"We are reducing the spillage of grain as it travels west," Feigel said. "We believe we are on the right path to making a difference."

Parks Canada says dealing with grain spills is important, but it's only part of the solution. Bears and other wildlife are well accustomed to using the tracks as a pathway. Canadian Pacific trains have been running through the area for 125 years.

Fencing off problem areas and building wildlife overpasses are reducing the number of bear deaths on the Trans-Canada Highway through Banff National Park. The same idea could work on the rail line, Hunt says.[19]

Bears are now handled and immobilized more humanely than in the past, yet still they lose their lives. We must make informed changes if there is to be a viable population of bears, particularly grizzly bears, in the mountain national parks. The loss of female bears is of particular concern, in both grizzly and black bear populations. It seems tragic that, in essence, many of these incredible animals lose their lives merely for the crimes of being wild and looking for food. If we are to protect the bears from ourselves, we must take action to bring attention to the issues at hand.

Maureen Enns

Artists are taking action to bring attention to the declining bear populations in the mountain national parks. One such artist

Grizzlies #2, Icefield Parkway,
Maureen Enns,
acrylic, charcoal, paper, glue on paper

Artist Maureen Enns, 2009

is Maureen Enns (1949 –), who lives near Cochrane, Alberta. Her work is featured here because she is one of the few contemporary artists in the Whyte Museum of the Canadian Rockies' collection whose primary subject is bears. Maureen Enns began her work with bears in Banff National Park in 1991. In *Grizzly Kingdom: An Artist's Encounter*, she details how for three years, "It was a full-time commitment to thinking about bears, searching for them, and finally reacting to their powerful presence." Since that time, she has worked with Canadian naturalist Charlie Russell, who is famous for his study of grizzly bears. Together

Flint's Park, Maureen Enns, graphite charcoal drawings, acrylic on paper, 1993

King of the Rockies, Maureen Enns, oil/acrylic on canvas

they have worked amongst the European brown bears on the remote Kamchatka Peninsula of Russia.

Tribute to Banff National Park, Maureen Enns, acrylic on canvas

Maureen started from a place of "bearanoia," but now concludes that there is too much fear-mongering about bears. She believes that serious misunderstandings about bears have brought on much of the fear. Ultimately, she feels that current attitudes and actions could lead to the extinction of grizzly bears. After working and living with bears for the past two decades, Maureen Enns understands that we need to "get back to enjoying these creatures in the wild."[20] In 2009, she is again working on art that focuses on the great bears of the Canadian Rocky Mountains.

What To Do When You Meet a Bear

Medicine woman Corleigh Belton relates the Stoney Nakoda perspective on what to do during a confrontation with a bear. As you will notice, it differs somewhat from the advice officially given in Canada's national parks.

If we meet up with a bear, we will look it right in the eye and talk to it. We might say, 'Sorry to have disturbed you, Grandfather, please let me be on my way' or 'Please continue on your way, I will take another path.'

Corleigh Belton's mother, Florence Powderface, remembers a story about a Stoney woman's interaction with bears:

Now I don't know if the woman couldn't have kids or what, but she was going for a walk and she came across three orphan baby bears, very tiny small ones, and she felt sorry for them, so she wrapped them up and took them home to her own tipi and she started to nurse them. She nursed the babies until they were about a year old, until they were old enough, and they stuck around her. They considered her the mother, you know, "this is my mom." So they lived with her . . . bear cubs stay with the mother for about two years. She talked to them in Stoney Lakota Sioux, and they heard, and they understood. They couldn't talk back, but they heard and understood, which comes to the conclusion where, remember I said to you that we can talk to bears and they understand us?[21]

Maureen Enns has an approach to dealing with bear encounters that aligns with the First Nations perspective. From her time living amongst bears, her connection to them and understanding of their behaviour has shaped her personal standpoint. She says that talking to the bear is one of the most important factors in avoiding a negative confrontation. Bear body language is also important to ensure that the bear understands that she is no threat. Observing bears turning one shoulder toward the other during a meeting in the wild, she advocates giving a bear the "cold shoulder." She further clarifies:

If you do come across a grizzly at close range, whatever you do, don't run – not anywhere, not even up a tree. Try talking quietly to the bear, while backing away slowly. If it charges – and only as a last resort if the animal is on top of you and your bear spray hasn't worked – play dead and cover your vital parts.[22]

Many bears in the Rocky Mountains may have experienced unpleasant encounters with human beings in the past. Keeping their lack of predictability in mind, Maureen advises that bear spray (pepper spray) should always be close at hand, but not aimed at the bear unless it charges. So far, she has never had to use the spray.

The Official Word

Mike Gibeau of the mountain national parks says that the current Parks Canada strategy for managing the safety of bears is to teach the bears to stay away from people through aversive conditioning: "Aversive conditioning is a non-lethal form of conditioning, using pain and noise stimuli, to promote increased wariness of habituated bears and subsequently reduce human caused bear mortalities." Gibeau acknowledges that the "fear-mongering" described by Enns may indeed be the by-product of some literature produced by Parks, but as a whole, Parks information about bears is excellent.[23]

In relation to bear encounters, Parks Canada's website (pc.gc.ca) elaborates on the following advice:

ALWAYS carry bear spray (pepper spray) with you on the trail

AVOID an encounter
➢ Make noise, travel in groups, watch for fresh bear markings
➢ Keep your dog on a leash *at all times*

NEVER approach a bear
➢ Always maintain a distance of at least 100 metres

IF you have to handle an encounter, SPEAK to the bear
➢ ALWAYS try to stay calm
➢ AVOID pointing the bear spray at the bear, but have it ready if you need it
➢ NEVER run from a bear, back away slowly

Parks Canada stresses that most encounters with bears end without injury, but you may increase your chances of survival by following the above guidelines. In general, Parks Canada outlines two types of attacks: defensive and predatory. The most common type of attack is a defensive one, which usually occurs when the bear is feeding, protecting its young and/or unaware of your presence. The bear attacks because you are a potential threat.

If a DEFENSIVE attack occurs:
- Use your BEAR SPRAY
- If the bear makes contact with you, PLAY DEAD!
- However, if the attack continues it may have shifted from defensive to predatory, so FIGHT BACK!

In the case of a PREDATORY attack:
- Try to ESCAPE into a building, car or up a tree
- If you cannot escape, DO NOT PLAY DEAD!
- Use BEAR SPRAY and FIGHT BACK!

That said, Parks Canada also acknowledges that it is very difficult to predict the best strategy to use.

Bear attack survivor Jack Turner agrees:

> In my opinion, all that advice they give you about whether to play dead or fight back is useless. When a bear attacks you, it's like being hit by a train. You have no time to do anything. You're not even thinking, you're just being thrown all over the place.[24]

At the very least, if a bear does attack, perhaps a few of these reminders may fly through your mind as a guideline for what to do. It is also important to reiterate that attacks are rare. Excessive warnings about them may create unnecessary fear. Remember, if a bear does attack, the human may survive but the confrontation is likely to end with the death of the bear. Do your part; try to avoid confrontations.

CONCLUSION

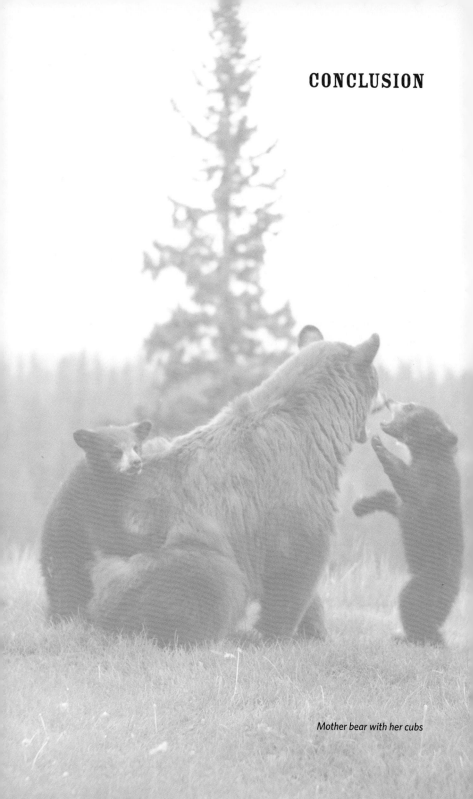

Mother bear with her cubs

Bears are a fact of life here in the Canadian Rockies. These mountains are their home. Since humans first inhabited this area, the bears have faced increasing threats to their habitat and survival. Over the past 100 years, we have gained a better understanding of bears and their habitat. Studies by scientists, such as Dr. Stephen Herrero, have increased our knowledge of bear populations, based on extensive monitoring and research. We know that bears are well adapted to living in the wilds of these mountains. Left to their own devices, they can flourish here. We also know it is human activity that puts their long-term survival in jeopardy.

Beginning with Andy Russell's *Grizzly Country*, books and other public information have increased popular knowledge of bears and gone a long way in changing our attitudes toward them. Although we still witness "bear jams" along the roadways, it appears that fewer people are feeding wildlife when they stop to look. Increased awareness has also resulted in greater control over hunting than in the past. Furthermore, in many areas, it is no longer legal to hunt grizzly bears. However, poaching is still a problem in some jurisdictions.

Whether frightening or enchanting, stories told by First Nations peoples and others who have encountered bears offer further insight into these extraordinary animals. As a result of attacks and near misses, we have learned to become much better at managing our food and garbage, thereby decreasing contact with bears. Our roads and railways continue to take the lives of wildlife, but underpasses and overpasses on highways are mitigating these impacts. Efforts to decrease grain spillage on railway tracks, at least in the national parks, are also making some headway.

Mike Gibeau eloquently describes the complexity of the human relationship with bears in one final note:

Bears bring out the best and the worst in people because they are symbolic of many of the ideals we hold, from being a symbol of the wilderness to one of the scariest beasts on earth. They symbolize strength, power, and independence. Bears are one of the few creatures that carry such symbolic meaning.

The Whyte Museum's collection of art, artifacts and archival materials reflects attitudes toward bears throughout the past hundred years. From souvenirs and trophies, to lovable clowns, to feared and revered, artists have helped to create and perpetuate our image of bears. Bears are a symbol of our relationship with the wilderness and wildlife. Their images are a reflection of our attitudes toward them.

Grizzly Walking, Dan Hudson, acrylic on canvas

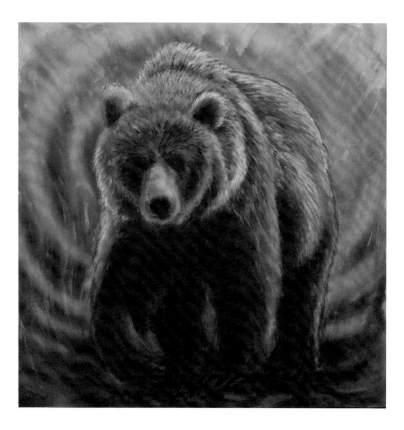

Grizzly, Dan Hudson, acrylic on canvas

BIBLIOGRAPHY

Auger, Dale, and Mary-Beth Laviolette. *Medicine Paint: The Art of Dale Auger*. Surrey: Heritage House Publishing Co. Ltd., 2009.

Alberta Heritage Community Foundation. "Banff Park Museum and National Historic Site." AlbertaSource Websites. http://abheritage.ca/abnature/mountains/featured_banff_museum.htm (accessed December 28, 2009).

Barbeau, Charles Marius. *Indian Days on the Western Prairies*. National Museum of Canada Bulletin No. 163. Ottawa: Department of Secretary of State, National Museum of Canada, 1965.

Bertch, Barbara, and Mike Gibeau. "Grizzly Bear Monitoring in the Mountain National Parks: Mortalities and Bear/Human Encounters 1990–2008." Second Annual Report, May 2009. Gatineau, Quebec: Parks Canada, 2009.

Bow Valley Wildsmart. "Aversive Conditioning: History of Bear Management." www.wildsmart.ca/programs/aversive_conditioning.htm (accessed December 30, 2009).

Boyden, Joseph. *Three Day Road*. New York: Penguin, 2006.

Banff Crag and Canyon, "Brace of Bruin Triplets Entertain Visitors," August 23, 1961, sec. 1.

Brinkley, Mabel. *In the Shadow of the Peaks*. Banff: Whyte Museum of the Canadian Rockies, 1950.

Chumak, Sebastian. *The Stonies of Alberta: An Illustrated Heritage of Genesis, Myths, Legends, Folklore and Wisdom of Yahey Wichastabi, (Mountain Stonies), the People-Who-Cook-with-Hot-Stones*. Calgary: The Alberta Foundation, 1983.

Cotter, John. "Parks Canada, Canadian Pacific Railway work on ideas to cut grizzly bear deaths," *Prince Albert Daily Herald*, Prince Albert, Sask., December 25, 2009.

Department of Interior, Canada. *Annual Report*. Ottawa: Government of Canada, 1907.

Department of Interior, Canada. *Annual Report*. Ottawa: Government of Canada, 1913.

Enns, Maureen, and Charlie Russell. *Grizzly Seasons: Life with the Brown Bears of Kamchatka*: Toronto: Random House Canada Ltd., 2003.

Gailus, Jeff. "Bear-ly with Us." *Westworld Alberta*, April 2009.

Gibeau, Mike. Interview by author. Personal interview. Whyte Museum of the Canadian Rockies, September 29, 2009.

Gibeau, Mike, and Robin Munro. *Summary Analysis of Translocating Bears*. Banff: Parks Canada, 1999.

Giddie, J.M. *Memorandum*. Ottawa: Canada National Parks Bureau, Whyte Museum of the Canadian Rockies, 1944 (M499, Accn. 6187).

Banff Crag and Canyon, "Grizzlies Laid Low," June 8, 1918, vol. XIX, no. 13, sec. 1.

Hart, E.J. *Jimmy Simpson*. Calgary: Rocky Mountain Books, 2009.

Banff Crag and Canyon, "Head Jammed Inside Milk Can, Bear Had to be Destroyed," October 8, 1943, sec. 1.

Herrero, Stephen. *Bear Attacks: Their Causes and Avoidance*. Revised ed. Toronto: McClelland & Stewart Ltd., 2003.

Holroyd, J.C. *Memorandum*. Ottawa: Canada National Parks Bureau, 1944. Whyte Museum of the Canadian Rockies, (M499, Accn. 6187).

Horsey, G.F. *Memorandum*. Ottawa: Canada National Parks Bureau, 1944. Whyte Museum of the Canadian Rockies, (M499, Accn. 6187).

Knight, Herbert. *Memorandum*. Ottawa: Canada National Parks Bureau, 1944. Whyte Museum of the Canadian Rockies, (M499, Accn. 6187).

"Last Call for the High Line Trail." *Trail Riders of the Canadian Rockies Bulletin*, No. 55, Fall 1939.

Luxton, Norman. Norman Luxton fonds. Banff: Eleanor Luxton Historical Foundation, 1960. Whyte Museum of the Canadian Rockies, (LUX/1A).

MacDonald, Jake. *Grizzlyville: Adventures in Bear Country*. Toronto: HarperCollins Canada, 2009.

Banff Crag and Canyon, "Man feeds Bear – Bear steals car," June 2, 1976, sec. 1.

Masterson, Linda. *Living with Bears: A Practical Guide to Bear Country*. Masonville, CO: PixyJack Press, 2006.

Parker, Elizabeth. "The Canadian Alps." *Calgary Herald*, July 25, 1901, sec. A.

"Parks Canada – Bear Management in the Rocky Mountain National Parks" Parcs Canada | Parks Canada. www.pc.gc.ca/docs/v-g/oursgest-bearmanag/page1_e.asp (accessed March 26, 2010).

Patterson, Bruce . "Two more mauled; earlier victim dies." *Calgary Herald*, October 2, 1980, sec. A.

Patterson, Bruce. "Bear strikes for a third time." *Calgary Herald*, October 4, 1980, sec. A.

Patterson, Bruce. "Black Bear Hunted after Man Killed." *Calgary Herald*, August 25, 1980, sec. A.

Patton, Brian. *Bear Tales from the Canadian Rockies*. Calgary: Fifth House Publishers, 1998.

Phillips, C.V. *Memorandum*. Ottawa: Canada National Parks Bureau, 1944. Whyte Museum of the Canadian Rockies, (M499, Accn. 6187).

Banff Crag and Canyon, "'Rumble Seat Red' Used on Too-Chummy Bears," July 27, 1960, sec. 1.

Russell, Andy. *Grizzly Country*. New York: The Lyons Press, 2000.

Russell, Charlie. *Grizzly Heart: Living without Fear among the Brown Bears of Kamchatka*. Toronto: Random House Canada Ltd., 2002.

Simpson, Jimmy. "Out on Deep, Soft Snow." *Unknown*, January 20, 2010. Whyte Museum of the Canadian Rockies Archives.

Snow, Chief John. *These Mountains Are Our Sacred Places: The Story of the Stoney Indians*. Toronto: Samuel Stevens, 1977.

University of Calgary. "The Art of Charlie Beil." University of Calgary Webdisk Server. http://people.ucalgary.ca/~cns/Beil.html (accessed December 28, 2009).

Alberta Heritage Community Foundation. "The Stoney Nakoda Nation Profiles – Walking Buffalo (George McLean)." Alberta Online Encyclopedia. albertasource.ca/treaty7/traditional/nakoda_buffalo.html (accessed October 6, 2009).

Thomas, Debbie, and Maureen Enns. *Grizzly Kingdom: An Artist's Encounter*. Calgary, Alberta: Detselig Enterprises, 1995.

Thompson, David. *David Thompson's Narrative, 1784–1812*. Publications of the Champlain Society, no. 40. Toronto: The Champlain Society, 1962.

Tighem, Kevin Van. *SuperGuide: Bears*. Calgary: Rocky Mountain Books, 2009.

Alberta Heritage Community Foundation. "Treaty 7: Past and Present." Alberta Online Encyclopedia. www.albertasource.ca/treaty7/treaty/treaty_read.html (accessed December 28, 2009).

Banff Crag and Canyon, "Wardens Kill Big Grizzly Bear North of Lake Louise: Had Been Making Frequent Raids on Camp 7 – Trailed Seven Miles through Snow," October 21, 1932, sec. 1.

"Winnie the Pooh." Wikipedia, the Free Encyclopedia. http://en.wikipedia.org/wiki/Winnie-the-Pooh (accessed January 6, 2010).

Jimmy Simpson, Mountain Man. DVD. Directed by Jon Whyte. Banff: Whyte Museum of the Canadian Rockies, 1996.

Banff Crag and Canyon, "Roadside Animal Act – Star Tourist Attraction," July 1, 1959.

NOTES

1 Gailus, "Bear-ly with Us," 29.

2 Russell, *Grizzly Country*, 203.

3 Chumak, *Stonies of Alberta*, 42.

4 Corleigh Belton and Florence Powderface, interview with Dagny Dubois, July 22, 2009.

5 Corleigh Belton and Florence Powderface, interview with Dagny Dubois, July 22, 2009.

6 Barbeau, *Indian Days on the Western Prairies*, 1960.

7 Auger and Laviolette, *Medicine Paint*, 120.

8 Boyden, *Three Day Road*, 37-38.

9 Hart, Jimmy Simpson, *Legend of the Rockies*, 66.

10 Ibid, 68, 69.

11 Van Tighem, *Bears*, 87.

12 Van Tighem, *Bears*, 90.

13 Van Tighem, *Bears*, 40-41.

14 Van Tighem, *Bears*, 39.

15 Peter and Catharine Whyte sound recordings, Nick Morant telling grizzly story, S37/14, August 10, 1950, Whyte Museum of the Canadian Rockies Archives, Banff.

16 Russell, *Grizzly Country*, 183.

17 Van Tighem, *Bears*, 40-41.

18 Bertch & Gibeau, "Grizzly Bear Monitoring in the Mountain National Parks," 2009.

19 Cotter, "Parks Canada, Canadian Pacific Railway work on ideas to cut grizzly bear deaths," 2009.

20 Maureen Enns (artist) in discussion with the author, August 20, 2009.

21 Corleigh Belton and Florence Powderface, interview with Dagny Dubois, July 22, 2009.

22 Thomas and Enns, *Grizzly Kingdom*, 183.

23 Mike Gibeau in discussion with the author, September 29, 2009.

24 MacDonald, *Grizzlyville*, 102.

IMAGE CREDITS

Page 6 Detail from "Grizzly, Dan Hudson, acrylic on canvas" collection of the artist

Page 8 "Captain Conrad O'Brien-ffrench and bear at Banff Nuisance Grounds" Moore Family fonds, Whyte Museum of the Canadian Rockies (V439/NA66-415)

Page 10 "Man feeding a bear" Bruno Engler fonds, Whyte Museum of the Canadian Rockies (V190/IIAii-11-8)

Page 11 "Map of Whyte Museum's collecting area" Andreas Korsos, Arctos Consulting, 2009

Page 12 "Mother grizzly and yearling cubs" Bill Vroom fonds, Whyte Museum of the Canadian Rockies (V659/PB-4) (O.S.)

Page 13 "Black Bear and its track, Lynne Huras, dry pastel, acrylic, acrylic medium on paper" Whyte Museum of the Canadian Rockies, 2009

Page 14 "Grizzly Bear and its track, Lynne Huras, dry pastel, acrylic, acrylic medium on paper" Whyte Museum of the Canadian Rockies, 2009

Page 15 "A black bear standing on hind legs" Bruno Engler fonds, Whyte Museum of the Canadian Rockies (V190/IIAii-11-12)

Page 16 "Grizzly cub rears and looks at camera in curiosity" Bill Vroom fonds, Whyte Museum of the Canadian Rockies (V659/PB-2) (O.S)

Page 17 "Postcard of black bear in Wild Game series, J. Fred Spalding, photographer" The Camera Products Co., Vancouver, BC, Whyte Museum of the Canadian Rockies (V466/PG-C14-6)

Page 18 "Grizzly bear" Bruno Engler fonds, Whyte Museum of the Canadian Rockies (V190/4-16-2)

Page 19 "Snow Lily, Annora Brown, watercolour on paper" Whyte Museum of the Canadian Rockies (BWA.05.03)

Page 20 "Spring beauty, lantern slide" Mary Schäffer fonds, Whyte Museum of the Canadian Rockies, (V527/PS-551)

Page 21 "Bear with snow on his rump" Bruno Engler fonds, Whyte Museum of the Canadian Rockies (V190/BOX 4-16-3)

Page 22 "Grizzly bear chewing on a branch" Bruno Engler fonds, Whyte Museum of the Canadian Rockies (V190/BOX 4-16-5)

Page 23 "Golfers are not the only players on the course, Jasper Park, Canadian Rockies" Jasper National Park, Canadian Rockies

Page 24 "'Golf' at Jasper Park Lodge, Jasper National Park" Whyte Museum of the Canadian Rockies (PG-C63-3)

Page 24 "Grizzly bear dragging a branch in the river" Bruno Engler fonds, Whyte Museum of the Canadian Rockies (V190 box 4-16-4)

Page 26 "Brown bear necklace in birchbark basket" Whyte Museum of the Canadian Rockies
 (103.01.1013; 102-04.1001)

Page 28 "Necklace of grizzly bear teeth and beads, strung on a thong of buckskin" bought by
 Peter Whyte from Chief Dan Wildman, Whyte Museum of the Canadian Rockies
 (103.01.0053)

Page 29 "Chief Dan Wildman wearing necklace made of grizzly bear teeth, 1930, Catharine
 Robb Whyte, oil on canvas" Whyte Museum of the Canadian Rockies (WYC.02.01)

Page 30 "Excerpt from Catharine Robb Whyte's letters to her mother – October 21, 1930"
 Whyte Museum of the Canadian Rockies (M36/84)

Page 32 "Chief Hector Crawler (Calf Child), 1931, Peter Whyte, oil on canvas" Whyte
 Museum of the Canadian Rockies (WYP.02.17)

Page 33 "Chief Walking Buffalo (George McLean), c1930s, Peter Whyte, oil on canvas"
 Whyte Museum of the Canadian Rockies (WYP.02.62)

Page 36 "Big Bear Medicine, 1998, Dale Auger, acrylic on canvas" Whyte Museum of the
 Canadian Rockies (AUD.12.01)

Page 38 "Bear Sketch, July 25, 1943, Carl Rungius, pencil on paper" Whyte Museum of the
 Canadian Rockies (RUC.03.02)

Page 40 "Jimmy Simpson, guide and outfitter for Carl Rungius, Nicholas de Grandmaison,
 oil on canvas" Whyte Museum of the Canadian Rockies, (Accn. 7888)

Page 41 "Old Bald Face, 1935, Carl Rungius, etching on paper" Whyte Museum of the
 Canadian Rockies (RUC.04.05)

Page 42 "Wildlife artist Carl Rungius, inscribed 'To Pearl and Phil Moore with affectionate
 regards.'" Moore Family fonds, Whyte Museum of the Canadian Rockies (V439/
 NA-66-1313)

Page 43 "The Family, April 1937, Carl Rungius, etching on paper" Whyte Museum of the
 Canadian Rockies (RUC.04.06)

Page 44 "Carl Rungius sketching a bear" Jimmy Simpson family fonds, Whyte Museum of the
 Canadian Rockies (V577/PD2)

Page 44 "Black Bear and Woodsman, Clarence Tillenius, watercolour on paper" Whyte
 Museum of the Canadian Rockies, (TIC.05.01)

Page 45 "Takkakaw [sic] Falls, R.H. Palenske, etching on paper" Whyte Museum of the
 Canadian Rockies (PER.04.16)

Page 46 "R.H. Palenske, c1930s, in a Trail Riders of the Canadian Rockies camp" Byron
 Harmon fonds, Whyte Museum of the Canadian Rockies (V263/NA-6006)

Page 47 "Bear sketch, excerpt from page of sketchbook, Charles A. Beil, c1930, pencil on
 paper" Whyte Museum of the Canadian Rockies (BEC.03.04)

Page 47 "Grizzly Bear, Charles A. Beil, Bronze" Whyte Museum of the Canadian Rockies
 (BEC.06.08)

Page 47 "Charlie Beil working in his Banff studio" Whyte Museum of the Canadian Rockies,
 (V496/PA463-25)

Page 60 "Big group posing beside bear cub chained to a pole" Pat Brewster fonds, Whyte Museum of the Canadian Rockies (V91/495(PG) Accn. 80)

Page 60 "Mrs. Frank Freeborn and black bear at Mt. Stephen House, Field, B.C." Frank W. Freeborn, Alpine Club of Canada fonds, Whyte Museum of the Canadian Rockies (V14/NA66-417)

Page 61 "'Jasper, the bear' cartoon postcard" James Nathaniel Simpkins, Whyte Museum of the Canadian Rockies (V375/PG49-18)

Page 62 "Bear in a car" Byron Harmon fonds, Whyte Museum of the Canadian Rockies (V263/NA71-2880)

Page 62 "Bear cubs by car with mother looking on" Mary Schäffer fonds, Whyte Museum of the Canadian Rockies (V527/PS-495)

Page 63 "Bear up a tree" Bill Gibbons fonds, Whyte Museum of the Canadian Rockies (V227/3584)

Page 64 "Postcard of bear in the Canadian Rocky Mountains, c1929" Folkard Company of Canada Limited, Montreal, Whyte Museum of the Canadian Rockies (V466/PG-F71-7)

Page 65 "Text on back of postcard of bear in the Canadian Rocky Mountains, c1929" Folkard Company of Canada Limited, Montreal, Whyte Museum of the Canadian Rockies (V466/PG-F71-7)

Page 66 "'Four of a Kind, Jasper Park' postcard, c1940s, likely the same cubs as in Warden Phillips's tale" G. Morris Taylor, Whyte Museum of the Canadian Rockies, (V391/PG-94)

Page 67 "A Bear of a Traffic Cop at Johnson's Canyon [sic] near Banff, Alberta" The Camera Products Co., Vancouver, BC, Whyte Museum of the Canadian Rockies (V466/PG-C14-1)

Page 68 "Elsie Brooks feeding a bear" Byron Harmon fonds, Whyte Museum of the Canadian Rockies (V263/NA71-2893)

Page 69 "Black bear by car" Mary Schäffer fonds, Whyte Museum of the Canadian Rockies (V527/PS-515)

Page 70 "Woman in Hudson's Bay blanket coat feeding a black bear cub" George Noble fonds, Whyte Museum of the Canadian Rockies (V469/1558)

Page 70 "Mounted Police Officer feeding a bear before it was illegal to do so" George Noble fonds, Whyte Museum of the Canadian Rockies (V469/1526)

Page 71 "Postcard of black bear and cubs, Byron Harmon Photos, Banff, Canada" Whyte Museum of the Canadian Rockies (V466/PG-B99-45)

Page 71 "Dancing with destiny" Bill Gibbons fonds, Whyte Museum of the Canadian Rockies (V227/3289)

Page 72 "Cub following family with children" Bruno Engler fonds, Whyte Museum of the Canadian Rockies (V190/IIAii-11-10)

Page 72 "Bear cub being fed by person in a car" Bruno Engler fonds, Whyte Museum of the Canadian Rockies (V190/IIAii-11-4)

Page 100 Bruce Patterson, *Calgary Herald*, October 4, 1980, sec. A

Page 102 Detail from "Grizzlies #2, Icefield Parkway, Maureen Enns, acrylic, charcoal, paper, glue on paper" Whyte Museum of the Canadian Rockies (New acquisition)

Page 103 "Three Bears, Peter Karsten, pencil on paper" Whyte Museum of the Canadian Rockies (KAP.03.02)

Page 104 "Andy Russell with some of his belongings donated to the Whyte Museum, 1994" Peter and Catharine Whyte Foundation fonds (V692 / C – 1994)

Page 107 "Grizzlies #2, Icefield Parkway, Maureen Enns, acrylic, charcoal, paper, glue on paper" Whyte Museum of the Canadian Rockies (New acquisition)

Page 108 "Artist Maureen Enns, 2009" photo courtesy of the artist

Page 108 "Flint's Park, Maureen Enns, graphite charcoal drawings, acrylic on paper, 1993" Maureen Enns Collection

Page 109 "King of the Rockies, Maureen Enns, oil/acrylic on canvas" Whyte Museum of the Canadian Rockies, 1993 (ENM.12.01)

Page 110 "Tribute to Banff National Park, Maureen Enns, acrylic on canvas" Whyte Museum of the Canadian Rockies, 1993 (ACCN 7976)

Page 114 "Mother bear with her cubs" Bruno Engler fonds, Whyte Museum of the Canadian Rockies (V190 IIAii-11-3)

Page 116 "Grizzly Walking, Dan Hudson, acrylic on canvas" collection of the artist

Page 117 "Grizzly, Dan Hudson, acrylic on canvas" collection of the artist